Edward S. Curtis
THE GREAT WARRIORS

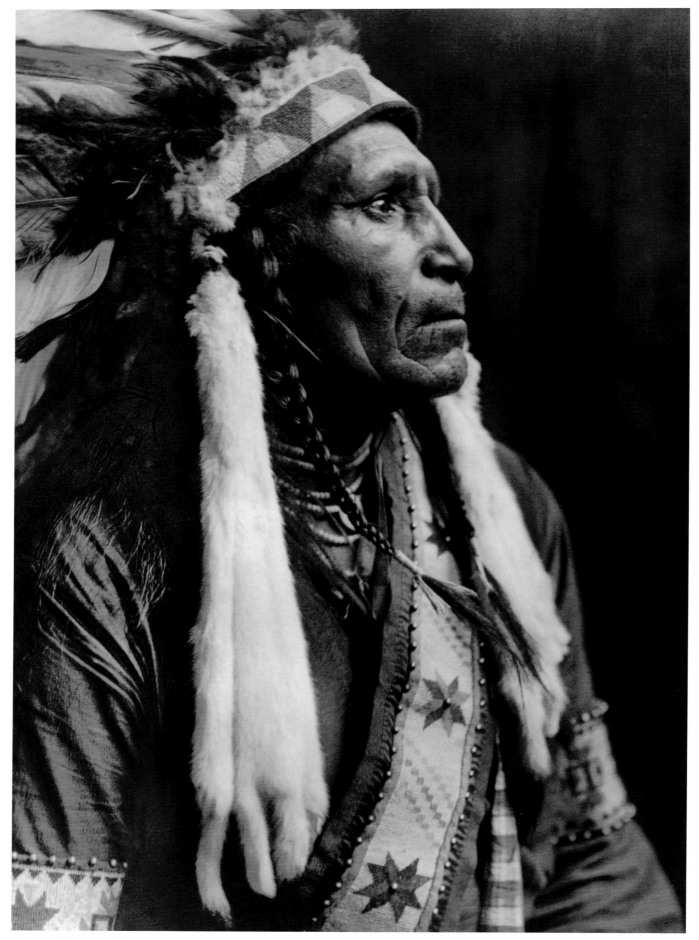

Raven Blanket—Nez Percé, 1910

Edward S. Curtis
THE GREAT WARRIORS

CHRISTOPHER CARDOZO

Foreword by Hartman Lomawaima
Afterword by Anne Makepeace

Bulfinch Press

New York · Boston

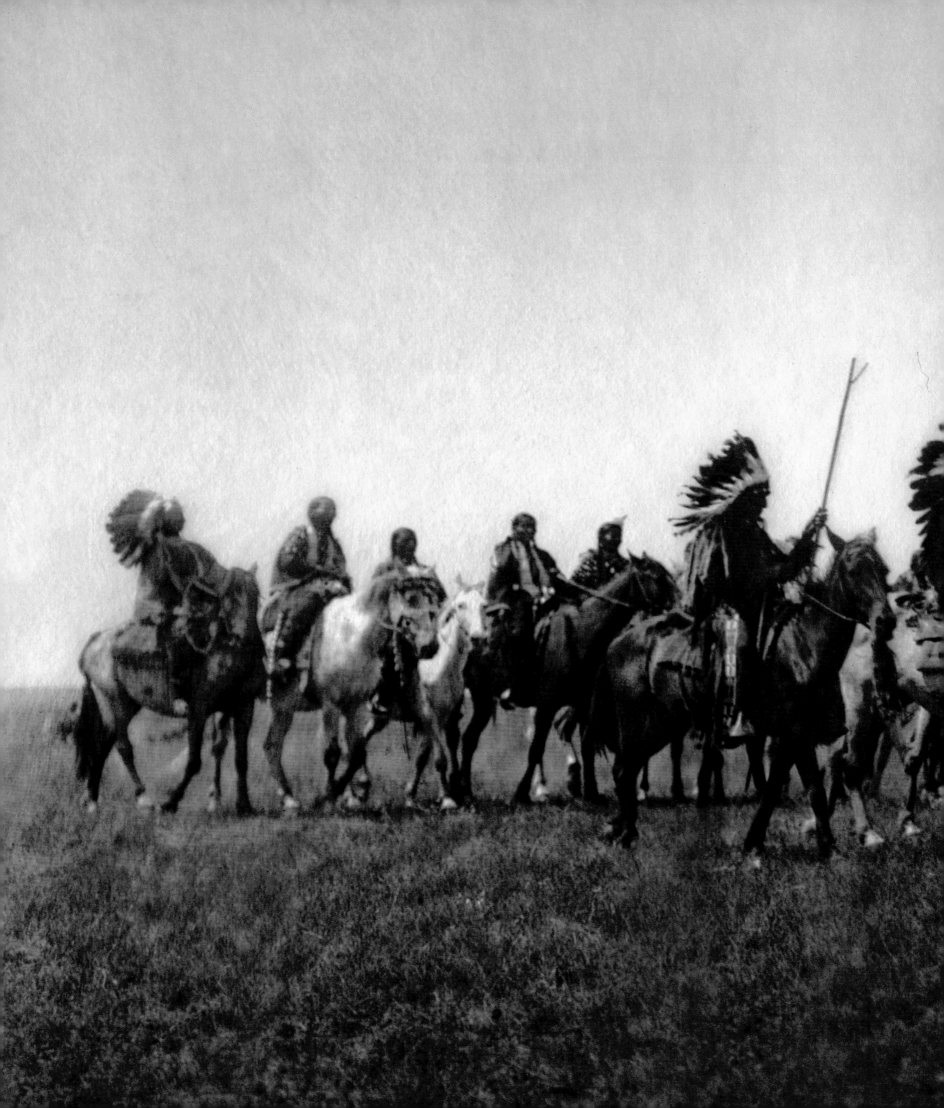

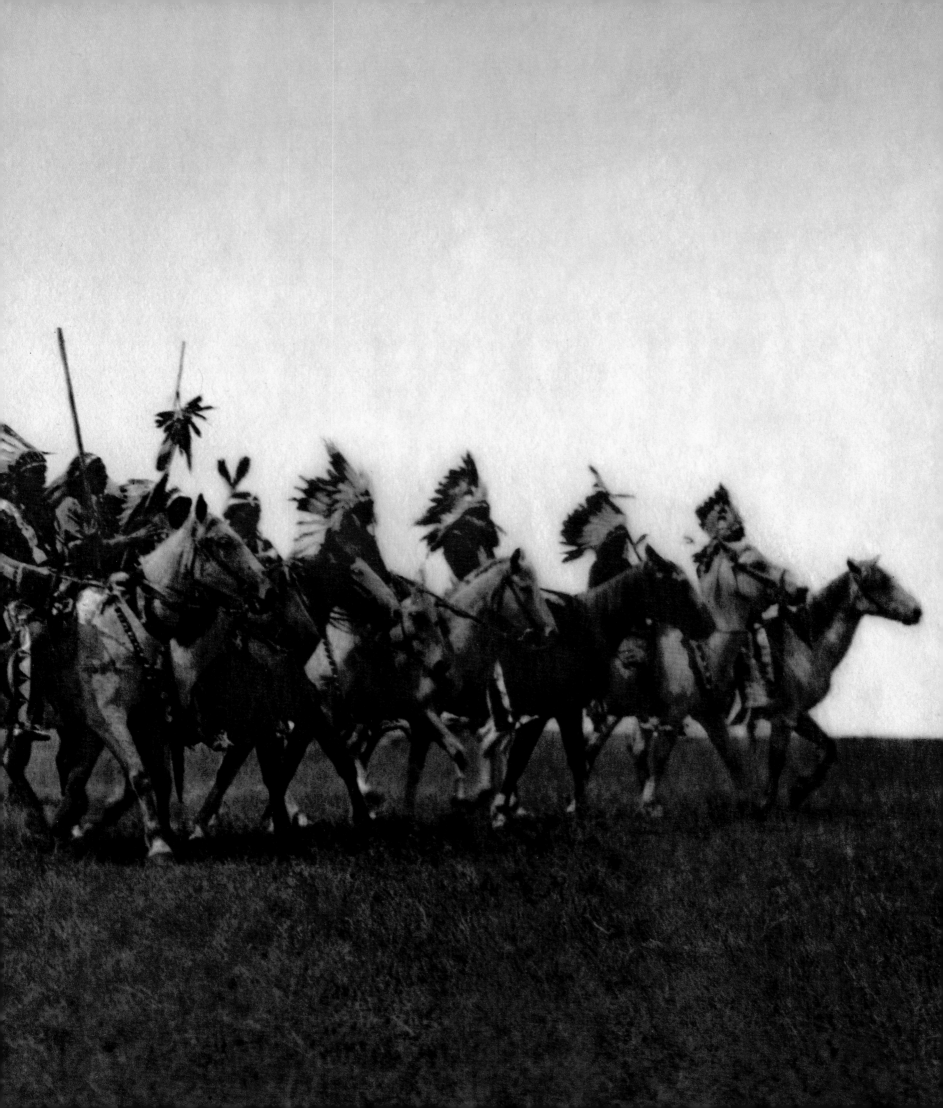

Foreword

Hartman Lomawaima

Every day, perhaps every hour of the day, someone in the world discovers the photography of Edward S. Curtis. My introduction to examples of Curtis' photogravures came in 1974. I was living in Palo Alto, California, at the time and met a gentleman who owned a small business doing bookbinding. He was a master at his craft and always had plenty to do. He called me one day to say that he had taken in two portraits of "Indian Chiefs" from a customer in exchange for binding services. I went to see the photographs and was smitten. One was of Slow Bull, an Oglala leader, and the other, Shot In the Hand, an Apsaroke leader. In my university training I had learned something of these remarkable men, but what really came through for me with utter clarity was the dignity and sophistication these men possessed. While I was not familiar with the northern and Great Plains regions of our country, I saw these photographs as a portal to a time, a place, and a people that I wanted to understand. My friend acquired a third photograph from his customer that featured Navajo men on horseback. The Southwest is my birthplace and this photograph was pleasing to me, as I often saw Navajo men traveling by horseback singing in precise unison, beautiful riding songs that were intended to make getting to one's destination safe, enjoyable, and seemingly faster. I would later learn that Curtis titled this image *The Vanishing Race*.

The digital pathway has made it possible to access images of American Indians and Alaska Natives, including the corpus of Curtis' work. However, there is no substitute for the personal experience of viewing a photograph from one of the original folios of the 20-volume set of *The North American Indian*. The experience is further accentuated when one reads the passages and song lyrics contained in the ethnographies that accompany the folios. Among the rich cultural resources at the Arizona State Museum in Tucson are two sets of *The North American Indian*. As a museum professional, I have had the privilege of working with extraordinary collections and remarkable people. In recent years I have had the pleasure of knowing and working with filmmaker Anne Makepeace, a truly remarkable person. As a Hopi man, I have lived in Sipaulovi, a village photographed by Curtis, and have strong family ties to all the Hopi villages depicted in Volume XII of *The North American Indian*. I have often wondered what it would have been like to have met Curtis as did some of my relatives. Would I have sat for him? Probably not. It would not have been the Sipaulovi way. I did agree to serve

as humanities scholar and consultant to Makepeace's Curtis film project, *Coming to Light*. I saw the project, in part, as a vehicle to return or repatriate images of a people to the places where the photographs were taken and to the descendants of those photographed. Makepeace adopted this approach and the finished product became a remarkable, humanistic documentary film of a diverse people who have dealt with changes of every magnitude in diverse ways.

During the film's production stage, Makepeace extended to me several invitations for an on-camera interview. I always managed to find something "more urgent" to do elsewhere. After awhile she began to refer to me as the "vanishing Indian," an application of the concept that Curtis would not have understood.

The present volume emphasizes Indian leaders and leadership. Chief is a term that has been used historically and widely to identify remarkable people whose legacies have become part of the social and cultural fabric of people and communities that comprise Native North America today. It would be incomplete, if not indiscrete, to consider Chief Joseph, the remarkable Nez Percé leader, only as Joseph. Historically, many Indian leaders received their designation as chiefs and warriors from their admiring military foes, government agents, biographers, and photographers. Curtis, too, was called chief by his staff and close friends. It would not surprise me if Indian leaders of the time referred to Curtis as chief or something equivalent in their respective languages. Chief is not necessarily gender specific. In recent times the term chief, or specifically Principal Chief, has been applied to females elected to political offices of leadership. Leadership, tradition, religion, language skill, self-image, and far sightedness have brought us to our present position as American Indian and Alaska Native People. We continue

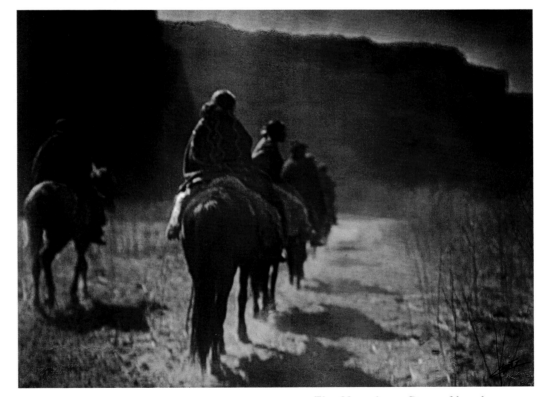

The Vanishing Race—Navaho, 1904

to demonstrate leadership in the ways of our ancestors. We also demonstrate leadership in other arenas such as museums, businesses, and civic organizations. The portraits that follow are of remarkable people, photographed by a remarkable person. Choose your favorite portal and begin the rewarding journey of understanding and appreciation. ❊

Edward S. Curtis: Aesthetic Vision

CHRISTOPHER CARDOZO

Under almost any definition of the word, Edward Curtis was, himself, a highly realized "warrior." He was also clearly drawn to a wide variety of other powerful men. Indeed, it was not uncommon for him to be in the field one week with Geronimo, Red Cloud, or Chief Joseph and then, a week or two later, be in New York weekending with President Roosevelt or meeting with J. Pierpont Morgan or Andrew Carnegie. Curtis himself was affectionately called "chief" by all his staff and many acquaintances. It is extraordinary that Curtis, having grown up in abject poverty and formally educated only to the sixth grade, achieved so much and was accepted into the highest echelons of both the oldest culture on the continent and one of the most powerful societies in the world.

It is estimated that Curtis made between 40,000 and 50,000 photographs of Native Americans during the period from 1895 to 1929. While evidence survives of only 3,000 to 4,000 of these negatives, one does not need to look far to see that male portraits and male figures in the landscape, as a whole, comprise Curtis' most frequent subject matter. His magnum opus, the illustrated set of rare books entitled *The North American Indian*, is replete with many hundreds of images of powerful Native American males: important chiefs and innumerable warriors, hunters, and scouts.

Curtis' photographs of Native American males can be broken down into several basic stylistic categories. As can be seen in the plate section that follows this introduction, the two most basic categories are the close-up portrait and the "peopled landscape." In the close-up portraits, Curtis most frequently photographed individuals from the waist up, with a fairly tightly cropped composition. (He also occasionally photographed an individual full figure, either in a portrait tent or in the landscape and, even less frequently, created a relatively intimate portrait of two or three subjects.) In the peopled landscapes, Curtis created photographs of individuals or groups of men within a broad landscape. These images typically illustrated men engaged in an activity, often hunting, fishing, or re-enacting warfare. These photographs often emphasize the landscape and/or activity as much or more than the specific individual(s) and thus, give further context to the person(s)' lives.

Curtis was both a consummate photographer and an accomplished artist. Thus, his best photographs evidence not only a solid grasp of the multitudinous technical aspects involved in realizing a beautiful print, but, also a mastery of the subtler and more elusive skills necessary to create works of art. This dual mastery is one of the core reasons his work has endured for over one hundred years and made him the most widely collected and published photographer in the history of photography. Obviously, the Native American subjects themselves are the other principal reason Curtis' work has stood the test of time. Their powerful presence, dignity, and emotional depth are all quintessential underpinnings of Curtis' photographs. That all these qualities come through so profoundly in Curtis' most compelling and evocative photographs is not only a testament to Curtis' technical and artistic mastery but, perhaps even more so, a reflection of the subjects themselves.

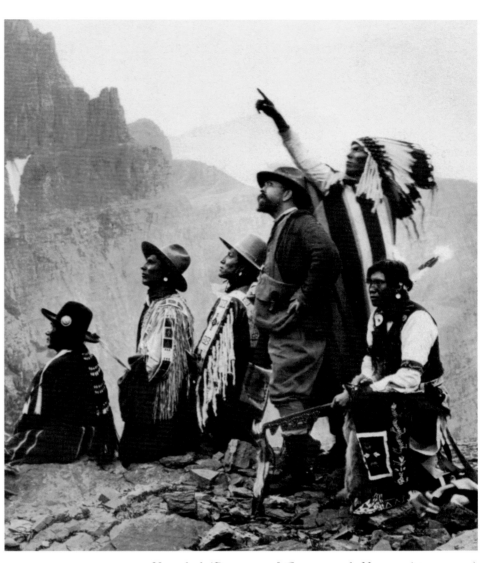

Untitled (Portrait of Curtis with Native Americans)

Curtis employed a number of aesthetic devices to convey the power, presence, and intensity of the people he encountered. As noted, the majority of his portraits are relatively closely cropped and show the subject in a carefully controlled aesthetic environment. This was generally created in the field within a large tent, using a dark backdrop and natural lighting. Curtis' portrait tent was equipped with louvers that could be adjusted to control the quantity and quality of the natural light in which he bathed his sitters. Curtis was initially trained, and first received renown, as a studio portrait photographer, and it was here he learned to exploit the aesthetic and emotional possibilities inherent in lighting and composition. Thus, even a cursory perusal of the portraits reproduced in this book reveals a photographer who was clearly drawn to classical, symmetrical compositions, and who generally used dramatic, focused lighting and deep, uncluttered backgrounds to convey the depth, beauty, and power of his sitters. Many of us have become so familiar with Curtis' photographs that we forget how extraordinary and unlike anything else they are. With the possible exception of a small body of work by A.C. Vroman, no other photographer of

the American Indian was able to consistently photograph his subjects in such an intimate and expressive way. The subjects were clearly active participants in the process with Curtis and their deep trust of the photographer and his project is reflected over and over again in the portraits. While Curtis was interested, as an ethnographer, in understanding human typologies, as an artist he was even more interested in conveying the depth and essence of the individuals he was photographing.

Curtis was greatly influenced by the Pictorialist movement in photography, an aesthetic propounded by a group of photographers whose goal was to distinguish their artistic endeavors from purely technical photographic pursuits. Curtis was not only an accomplished practitioner of Pictorialism, but also a noted theorist, contributing essays in Pictorialist aesthetics to scholarly and popular journals. The Pictorialists employed a wide variety of aesthetic devices to achieve their goals. Beyond the dramatic lighting and simplified and classical compositions discussed above, another important Pictorialist device was a softened focus, used to both minimize the purely documentary tendency of photography and to emphasize the emotional qualities of the subject matter. In addition to the softened focus, dramatic lighting, and classical composition that Curtis employed to convey his message, his nearly universal use of sepia toning was another significant aesthetic element. Clearly, the emotional quality of the rich sepia was in keeping with traditional Native American life (and what that life connotes to many contemporary viewers). When one views the rare, un-toned photograph by Curtis, the vastly different, and diminished, emotional impact is immediately apparent. In summary, Curtis' portraits of Native Americans are easily distinguished from those of any other photographer by their great intimacy, the emotional openness of the sitter, and a coherent aesthetic that put great emphasis on careful lighting; classic, simplified compositions; a warm, sepia tonality; and, frequently, softened focus. ❈

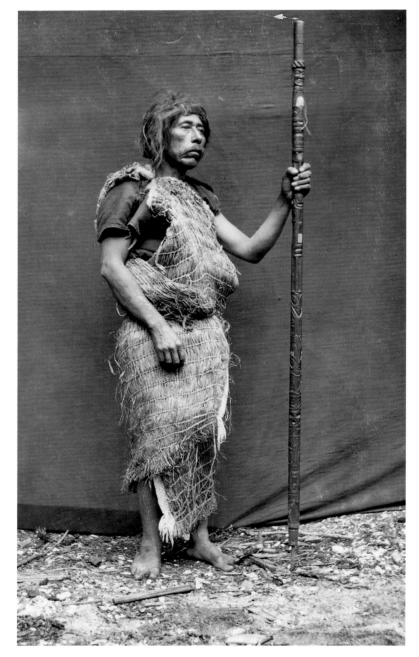

Untitled—Nootka, 1915

Edward S. Curtis: Shadow Catcher

CHRISTOPHER CARDOZO

"Be bold and the mighty forces will come to your aid." –GOETHE

Edward Curtis was born in 1868 in Whitewater, Wisconsin, the second of four children. His father, Reverend Johnson Curtis, returned from the Civil War in very poor health, and Curtis and his siblings grew up in abject poverty. Before Curtis turned five the family moved to southern Minnesota, where his father continued his vocation as an itinerant rural preacher. Most traditional Indian life had disappeared from Minnesota by the time Curtis and his family arrived in the 1870's, and there is no record of any Native American influence on Curtis' early life.

Curtis often accompanied his father on long treks to visit his far-flung congregation and these treks, which included frequent journeys by canoe, may well have been the inception of Curtis' love of the outdoors. At age twelve, Curtis built a camera by himself using a stereopticon lens his father had brought back from the Civil War. By his mid-teens, Curtis had experimented with, and studied extensively, many photographic techniques and theories. At seventeen, Curtis moved to St. Paul and became an apprentice photographer, and soon thereafter he was a serious and dedicated practitioner. Reverend Curtis' worsening health mandated a more temperate climate and the family chose the booming Pacific northwest. This move ultimately led to Curtis' discovery of traditional Native American life after the family settled in the Puget Sound area near Seattle.

Curtis' father's health was seriously weakened by the journey and he died shortly after the move. Responsibility for the family then fell primarily to Edward and for several years the family again lived a life of bare subsistence. However, through much hard work and diligence, the family managed to purchase a very modest homestead in 1890. Curtis soon secured a loan collateralized by the family homestead and used the proceeds to buy into a small Seattle photography studio. In 1892 Curtis married a family friend, Clara Phillips, and they began a family almost immediately.

By 1896 Curtis had bought out two partners and established himself as Seattle's foremost studio photographer. This success allowed him to spend time away from his studio to pursue his love of the great outdoors. While photographing the area's spectacular mountains and ocean scenery he first encountered small pockets of Native Americans still living somewhat traditional lifestyles. By 1898 Curtis had begun receiving recognition from both the general public and the photographic community for his Native American photographs, and that same year his Indian photographs came to the

attention of luminaries in the areas of conservation and ethnography. As a result, Curtis was invited to join a major scientific expedition in 1899 financed by railroad tycoon, E.H. Harriman. This expedition gave Curtis his first real grounding in the discipline and rigors of the scientific method.

By the turn of the century, his Seattle studio booming, Curtis' photographs of Indians began winning national awards. In the summer of 1900 Curtis accompanied George Bird Grinell to Montana to witness one of the last great enactments of the Sun Dance Ceremony. Grinell had spent twenty seasons in the field with the Blackfoot and Piegan, and had established a position of great trust that opened new doors for Curtis that fateful summer. This introduction to native rituals, spiritual beliefs, and the personal interactions between Curtis and several native individuals profoundly and inalterably changed the course of his life. On returning to Seattle, Curtis stayed only a few weeks before beginning his first self-financed, self-directed trip into the field: a journey to the Southwest to meet the Navajo, Apache, and Hopi peoples of Arizona. Thus, Curtis unwittingly embarked on a journey that was to consume the remainder of his career.

Curtis came to the attention of President Theodore Roosevelt in 1904 when he won a national portrait contest from among eighteen thousand entrants. Curtis soon photographed one of Roosevelt's children and quickly became close friends with the President. A great lover of the West, Roosevelt was very sympathetic to the plight of the American Indian, and he became an active champion of Curtis and his work. Curtis used a letter from Roosevelt in 1906 to approach J.P. Morgan, the man whose initial financial commitment made the first stages of Curtis' magnum opus, *The North American Indian*, possible. Each set of *The North American Indian* was entirely hand-made and hand-bound, and consisted of twenty photographically illustrated text volumes and twenty accompanying portfolios of oversized photographs. In all, each set of books contains 2,200 original photographs, thousands of pages of hand-printed text, and numerous transcriptions of language and music. The majority of the photographs in this book are drawn from *The North American Indian*.

In completing the twenty-five year project, Curtis encountered every imaginable hardship and endured great personal risk. It is difficult to imagine the enormity of Curtis' task: he made tens of thousands of negatives throughout remote areas of the western United States and Canada, many on large glass plates. He also acted as the project's principal ethnographer, fundraiser, publisher, and administrator. He wrote much of the nearly four thousand pages of ethnographic narrative. Grinnell, his friend and mentor, summed it up as follows:

"The pictures speak for themselves, and the artist who made them is devoted to his work...To accomplish it he has exchanged ease, comfort, home life, for the hardest kind of work, frequent and long-continued separation from his family, the wearing toil of travel through difficult regions, and finally the heartbreaking struggle of winning over to his purpose...people, to whom ambition, time and money mean nothing, but to whom a dream or a cloud in the sky, or a bird flying across the trail from the wrong direction means much."

The North American Indian is considered the most ambitious and sumptuous publication ever undertaken by a single man. In 1911, the *New York Herald* called it the most gigantic undertaking since the publication of the King James Edition of the Bible. J.P. Morgan's generous support, which ultimately greatly exceeded his initial commitment, was something of a double-edged sword: it gave Curtis enough money to begin the project, but also dissuaded other potential patrons from contributing their critically needed financial support. Unfortunately, Morgan's contributions covered only about thirty-five percent of the ultimate cost and Curtis was forced to struggle constantly to raise funds. To make matters worse, the great financial panic of 1907 wiped out much of the early momentum that was critical for the project's success. The initial financial trouble continued incessantly throughout the remaining twenty-three years of the project, which culminated in 1930. Nevertheless, Curtis constantly strived to keep his project afloat and, in addition to all his other duties he also maintained a grueling lecture and exhibition schedule, sold original photographs, and invested heavily in various efforts to prop up the disappointing sale of subscriptions for the limited-edition books. The expenses related to publishing the books were staggering, and from the beginning of World War I until 1921 the project was essentially moribund due to a nearly total lack of funds.

The craftsmanship and materials were of the highest possible quality, and Curtis selected the difficult and expensive process of photogravure for both the small volume and the large portfolio prints. The resulting expense of producing each set of the books caused the subscription price to rise to the same cost as a substantial private mansion. This in turn limited the number of subscriptions, compounding the steep shortfall in revenue. Of a projected five hundred sets, less than three hundred were actually produced, and only two hundred fourteen were sold during the time Curtis was involved in the project. It is estimated that he needed to sell four hundred sets just to break even. In today's dollars, it is estimated that the project cost a staggering $30-35 million.

Ever the entrepreneur, and being an exceptional photographic craftsman and a master printer, Curtis offered individual photographic prints (non-photogravure) to the public in the never-ending effort to raise funds. He had experimented with a number of different photographic techniques and he created a wide variety of individual photographs for sale, including platinum prints, silver prints, goldtones, and even an occasional hand-colored print. Sales of these prints helped to a small degree, and while Curtis managed to complete *The North American Indian* in 1930, the intensity with which he pursued his dream did little for his health or well-being. Having driven himself to the limit for many years, he suffered a nervous and physical breakdown soon after the project was completed. Following his recovery two years later, he spent the last twenty years of his life in Los Angeles with his beloved daughter Beth. He died in 1952, essentially unknown and penniless. Upon his death *The New York Times* issued a seventy-five word obituary that mentioned simply that "Mr. Curtis was a photographer." ❊

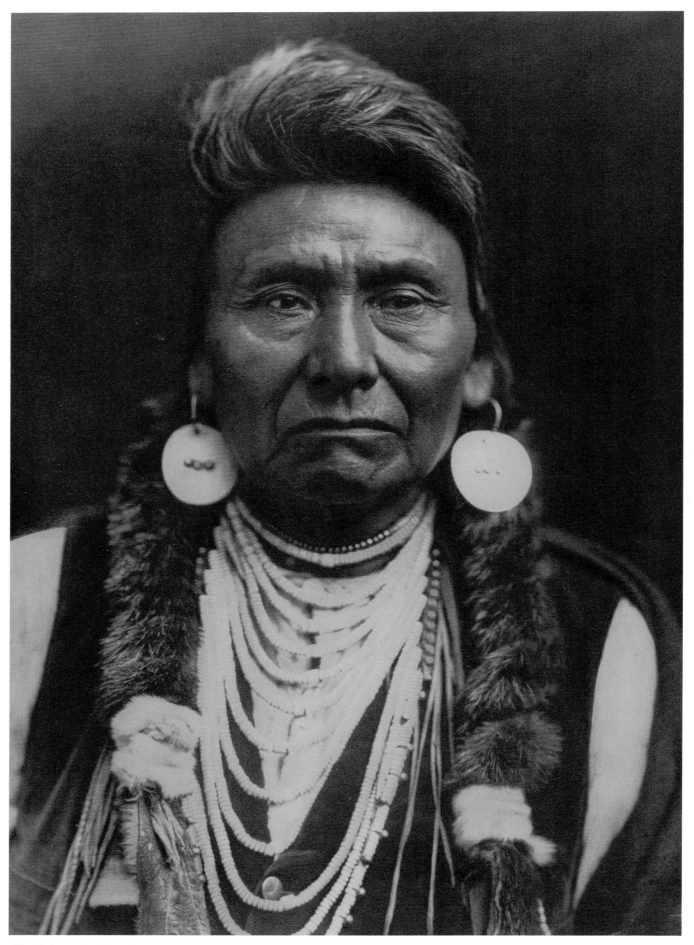

Chief Joseph—Nez Percé, 1903

PLATES

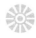

The idea of full dress in preparation for a battle comes not from a belief that it will add to the fighting ability. The preparation is for death, in case that should be the result of the conflict. Every Indian wants to look his best when he goes to meet the great Spirit, so the dressing up is done whether in imminent danger in an oncoming battle, or a sickness or injury at times of peace.

—Wooden Leg, Cheyenne

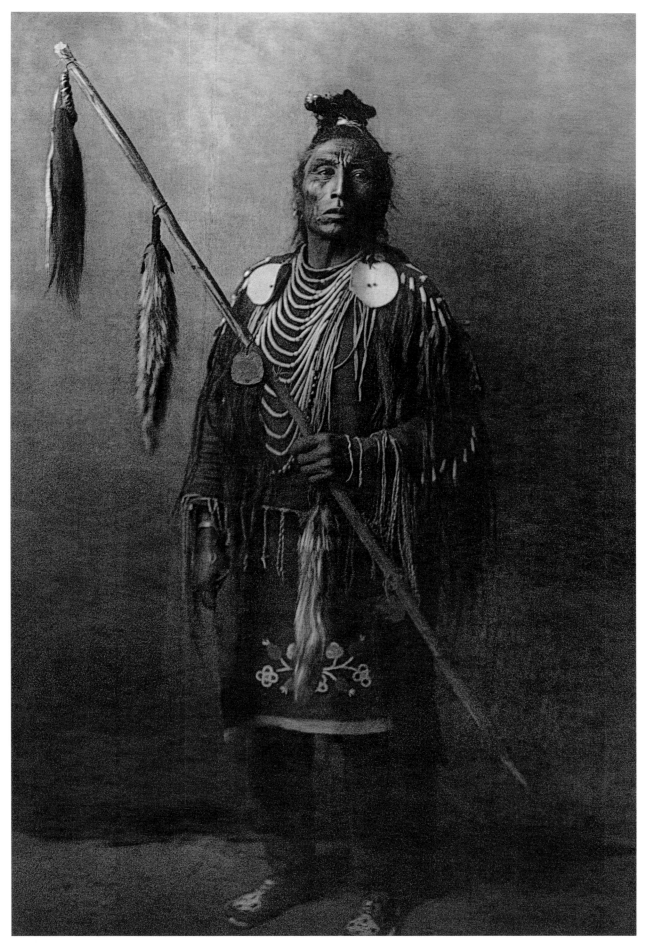

Apsaroke War Chief, 1909 Plate 1

Needing a bearskin in my medicine-making, I went, at the season when the leaves were turning brown, into the White-Clay hills. All the thought of my heart that day was to see a bear and kill him. I passed an eagle trap, but did not stop: it was a bear I wanted, not an eagle. Coming suddenly to the brink of a cliff I saw below me three bears. My heart wished to go two ways: I wanted a bear, but to fight three was hard. I decided to try it, and, descending, crept up to within forty yards of them, where I stopped to look around for a way of escape if they charged me. The only way out was by the cliff, and as I could not climb well in moccasins I removed them. One bear was standing with his side toward me, another was walking slowly toward him on the other side. I waited until the second one was close to the first and pulled the trigger. The farther one fell; the bullet had passed through the body of one and into the brain of the other. The wounded one charged, and I ran, loading my rifle, then turned and shot again, breaking his backbone. He lay there on the ground only ten paces from me and I could see his face twitching. A noise caused me to remember the third bear, which I saw rushing upon me only six or seven paces away. I was yelling to keep up my courage and the bear was growling in his anger. He rose on his hindlegs, and I shot, with my gun nearly touching his chest. He gave a howl and ran off. The bear with the broken back was dragging himself about with his forelegs, and I went to him and said, 'I came looking for you to by my friend, to be with me always.' Then I reloaded my gun and shot him through the head. His skin I kept, but the other two I sold.

—Bear's Belly

Bear's Belly—Arikara, 1909 Plate 2

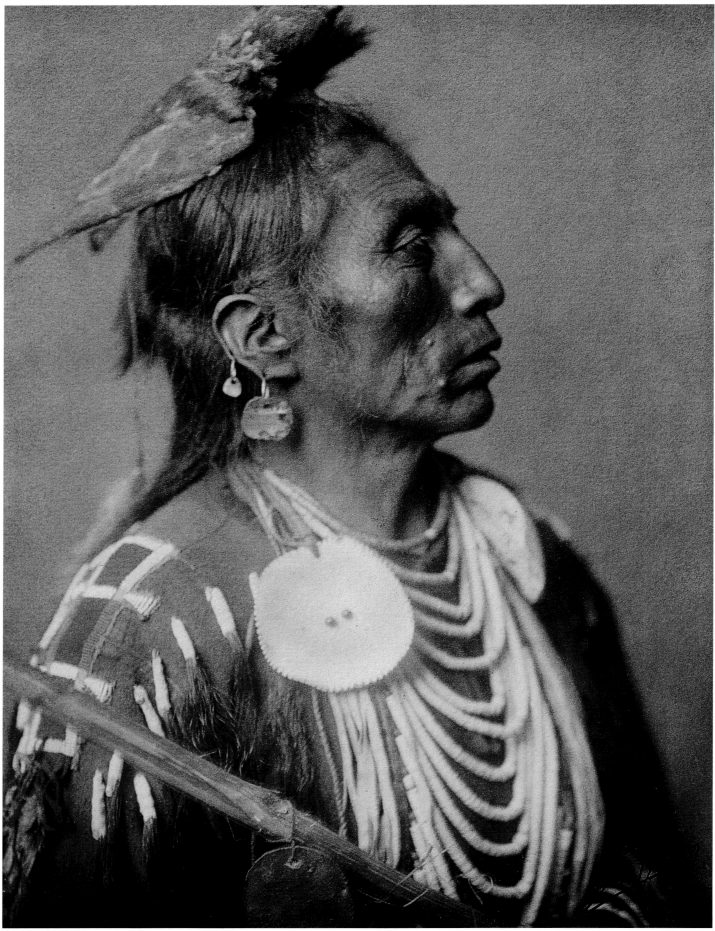

Medicine Crow—Apsaroke, 1909

Plate 3

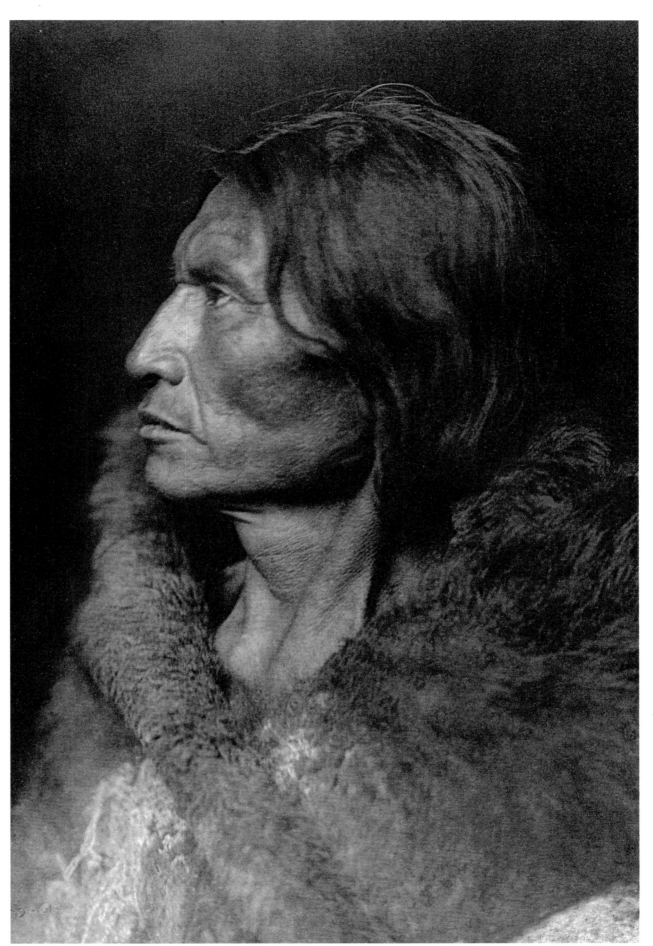

Mosquito Hawk—Assiniboin, 1908 Plate 4

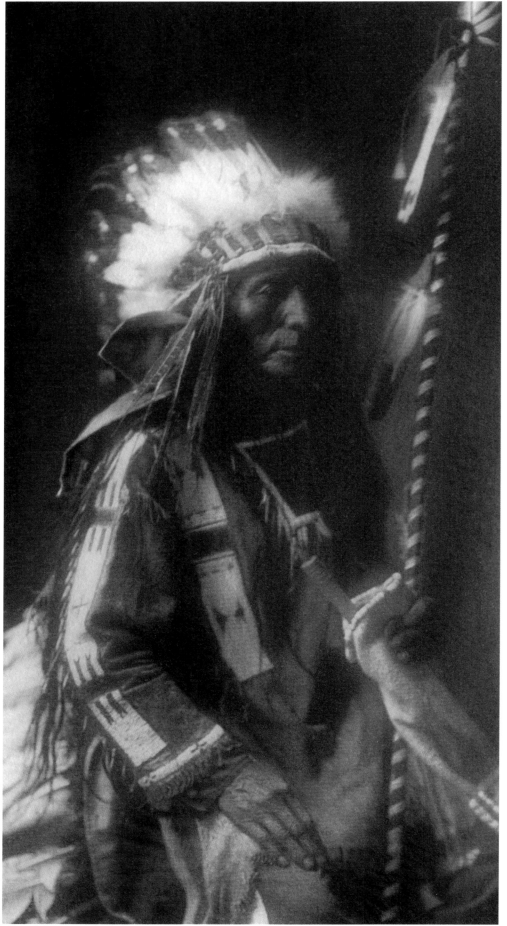

Good Lance—Oglala, 1908 Plate 5

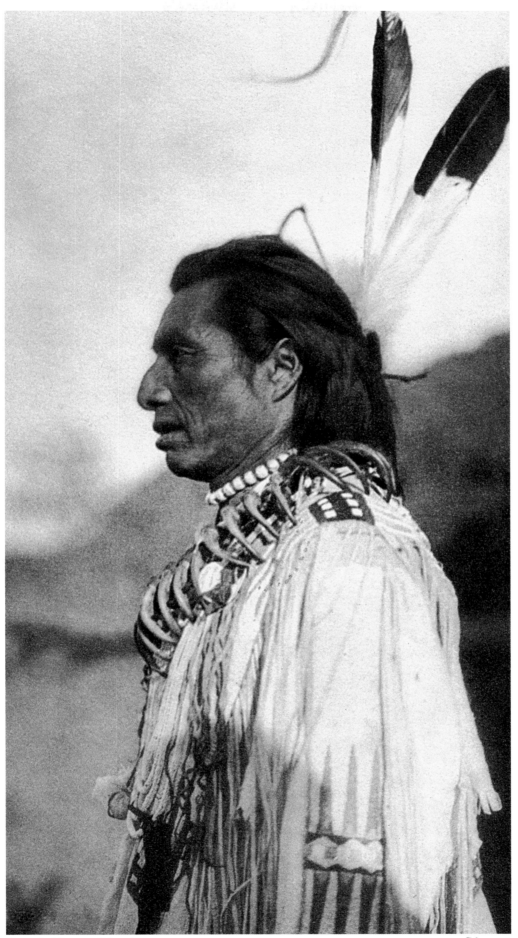

Crow's Heart—Mandan, 1909 Plate 6

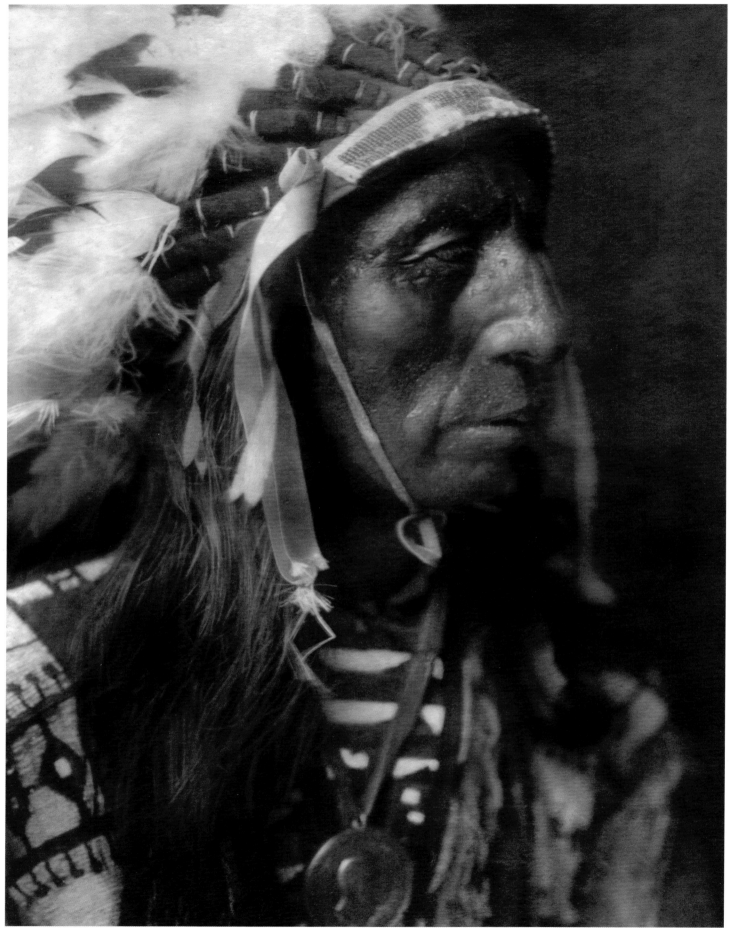

Jack Red Cloud, 1908

Plate 7

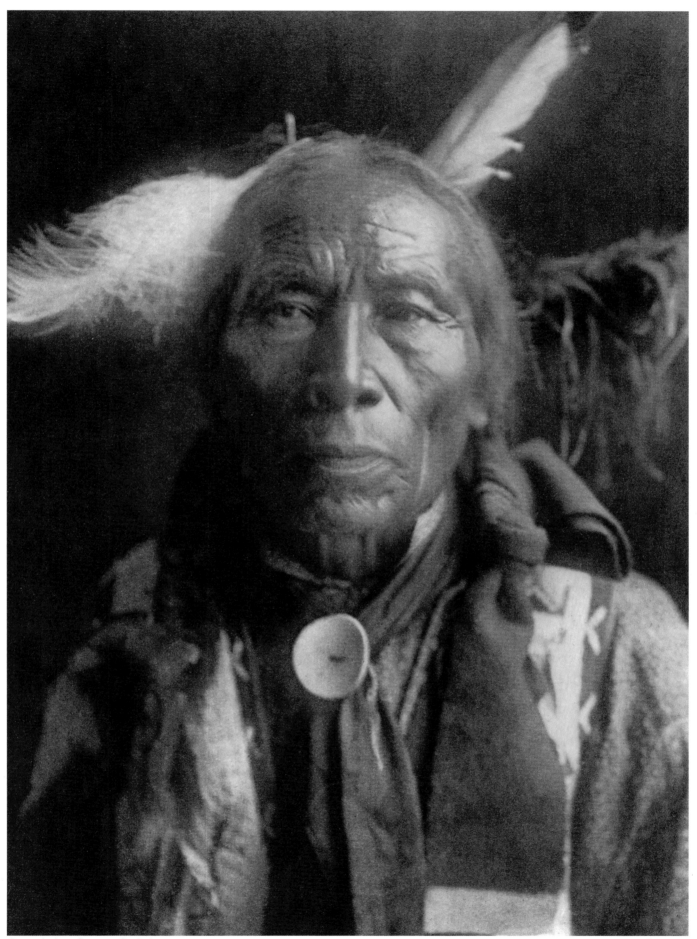

Struck by Crow—Oglala, 1908 Plate 8

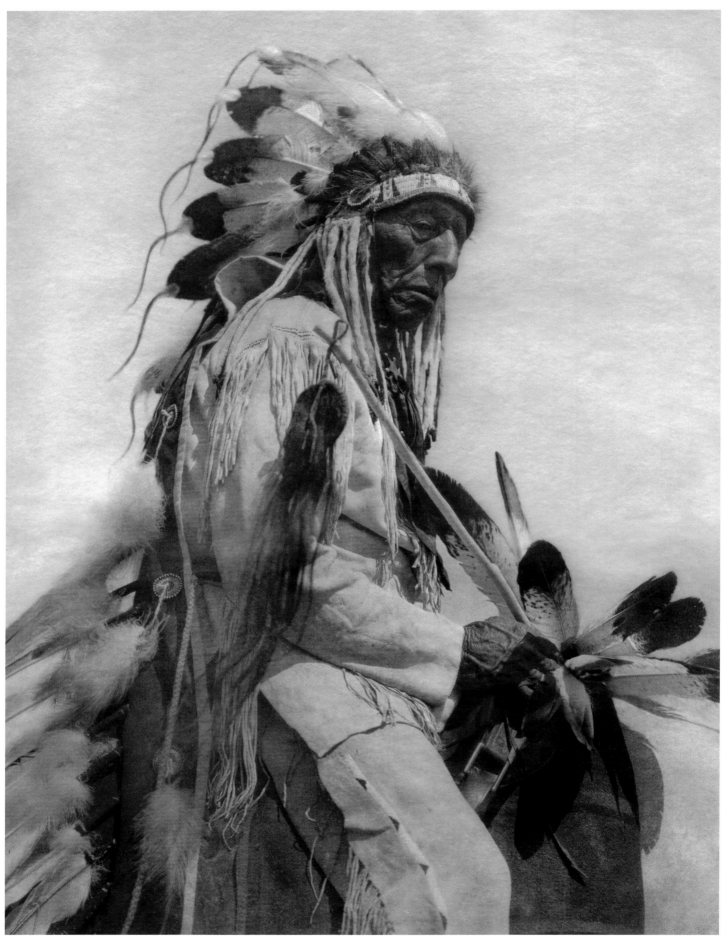

The Old Cheyenne, 1930 Plate 9

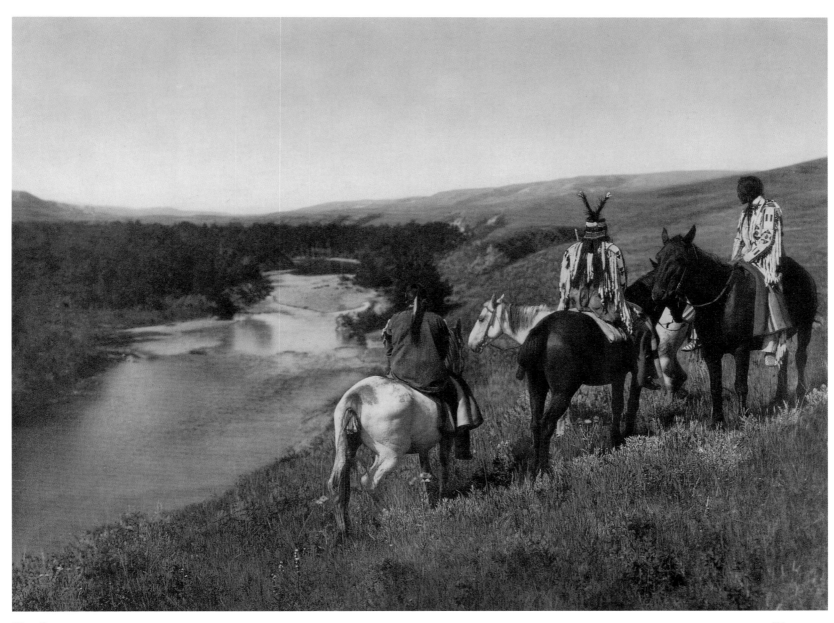

The Piegan, 1911 Plate 10

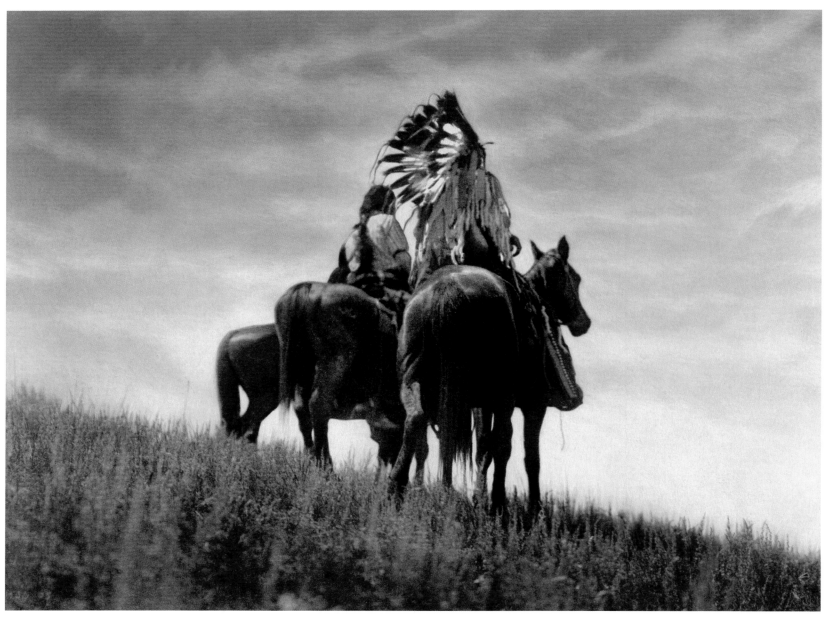

Cheyenne Warriors, 1911 Plate 11

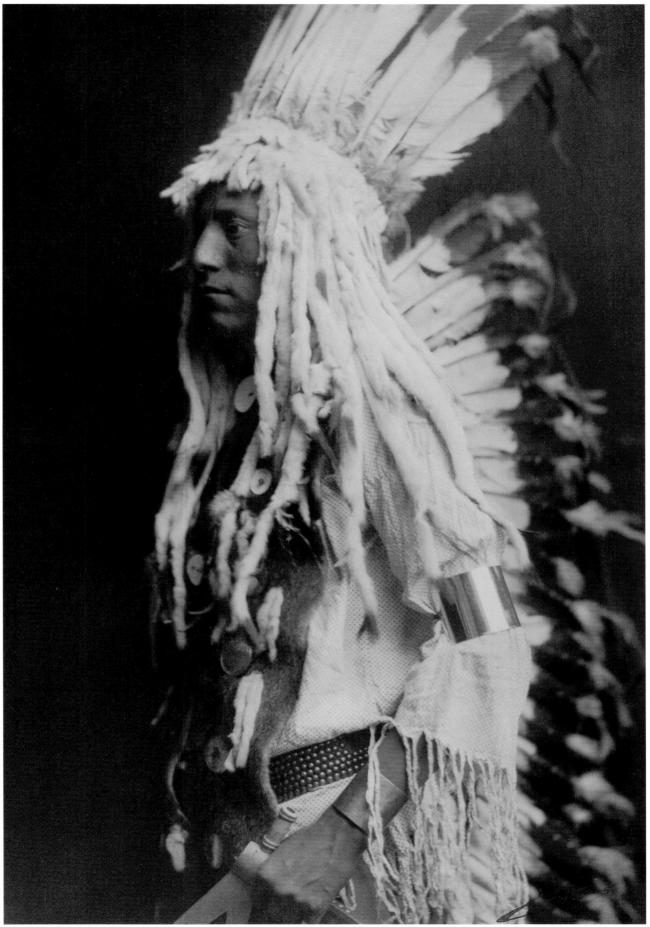

Old Person—Piegan, 1911 Plate 12

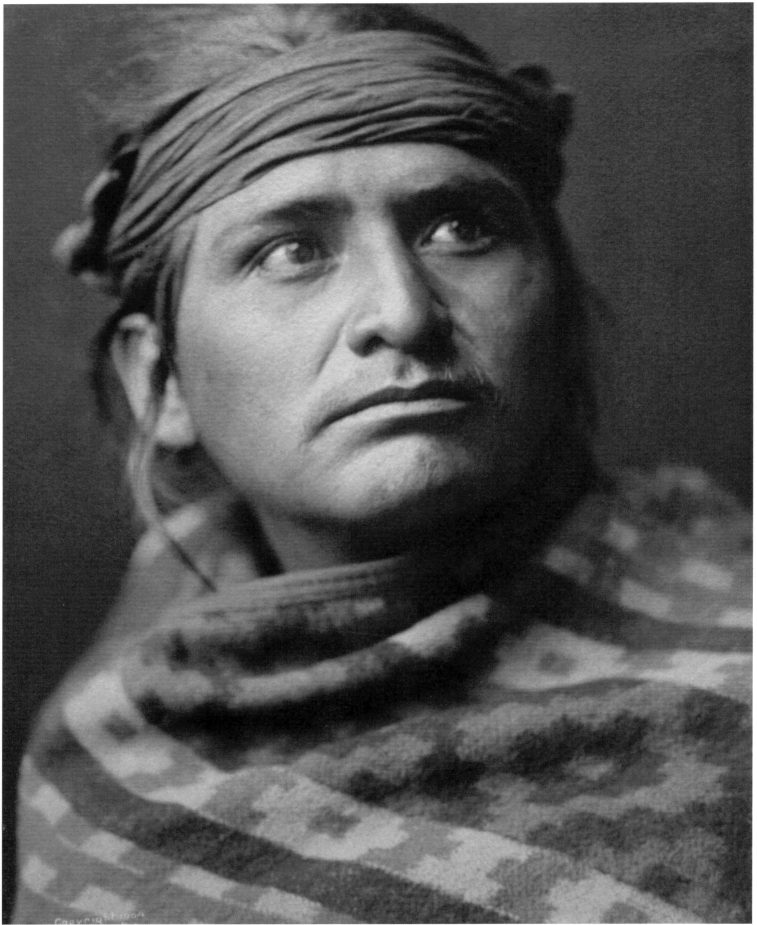

A Chief of the Desert—Navaho, 1907 Plate 13

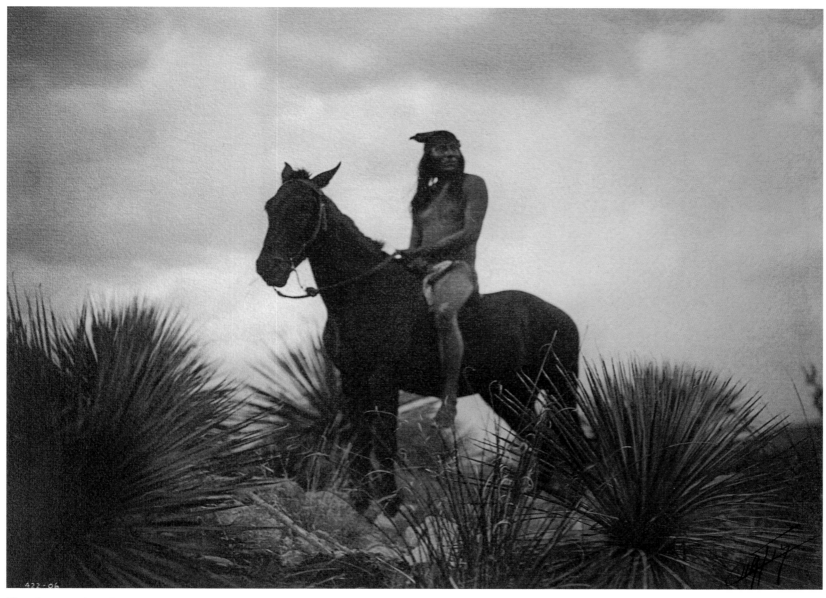

The Scout—Apache, 1907 Plate 14

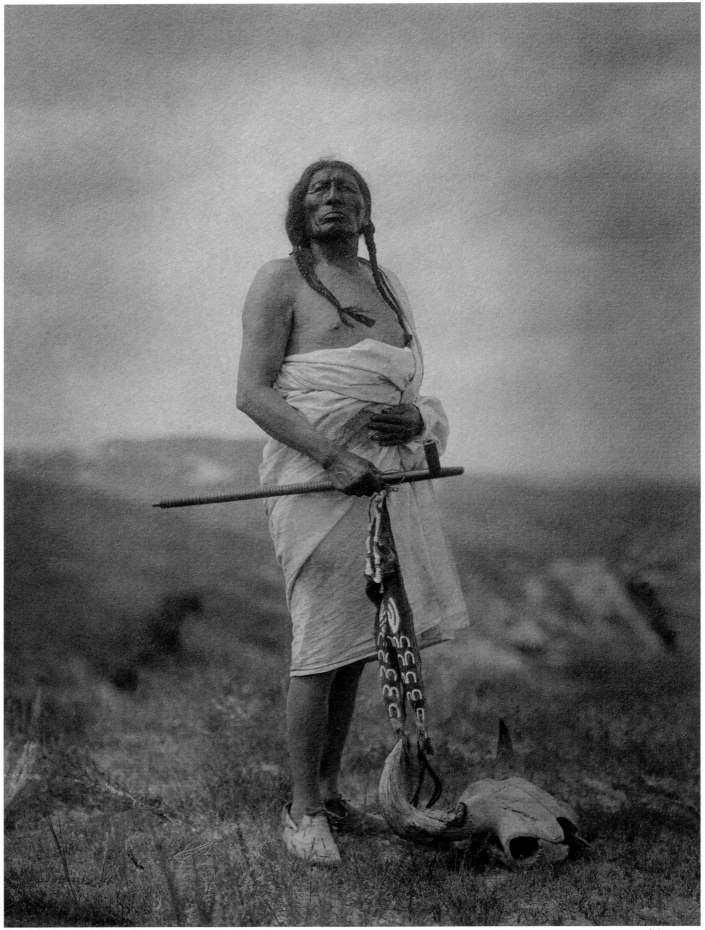

The Medicine Man—Sioux, 1908

Plate 15

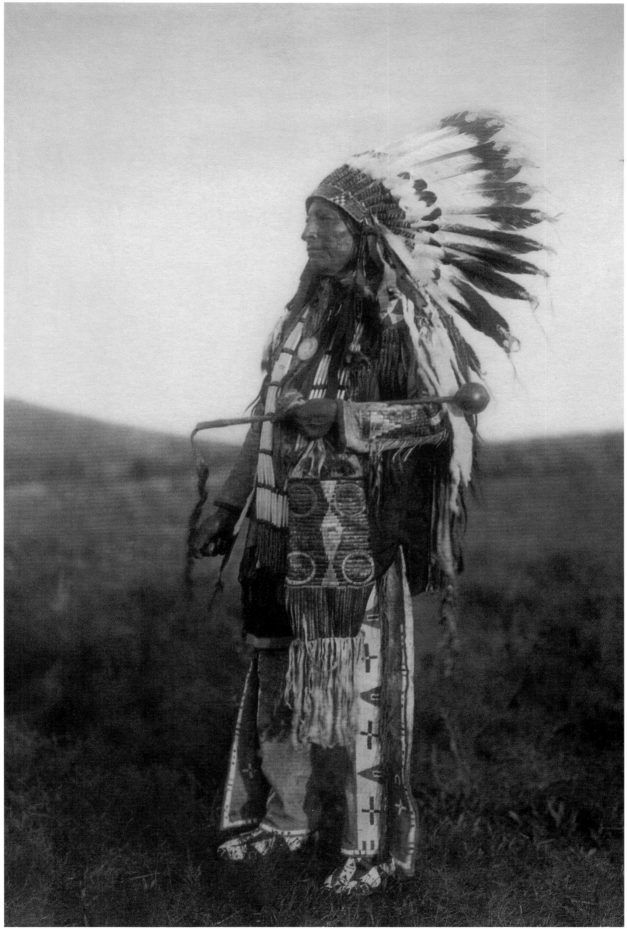

High Hawk, Brulé—Sioux, 1908 Plate 16

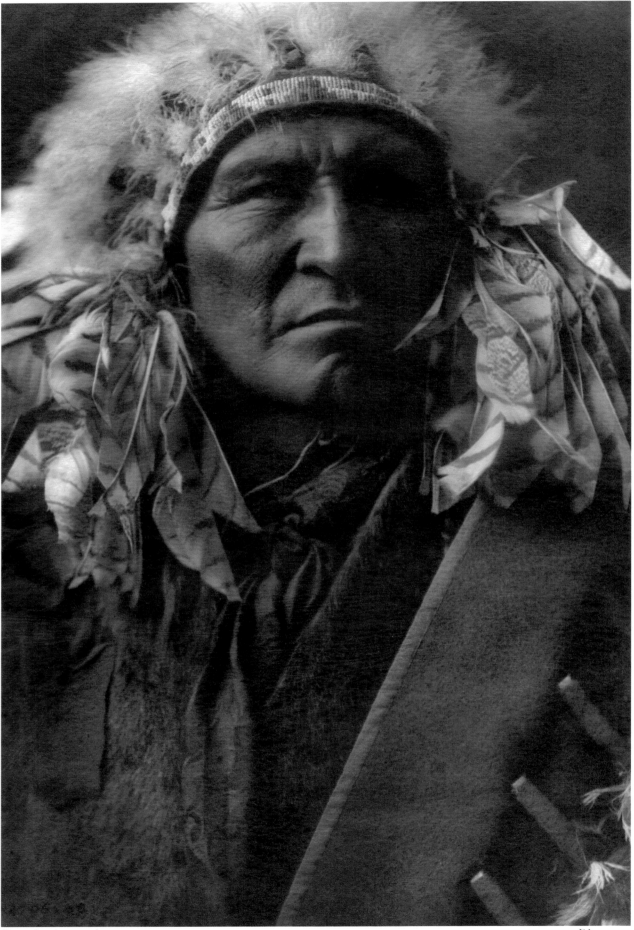

Bread—Apsaroke, 1909

Plate 17

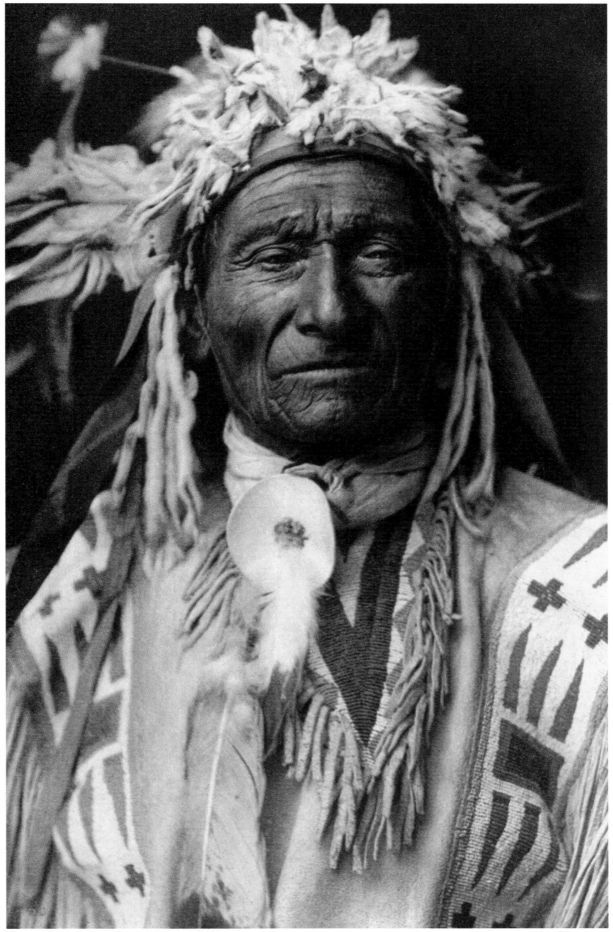

Long Fox—Assiniboin, 1908 Plate 18

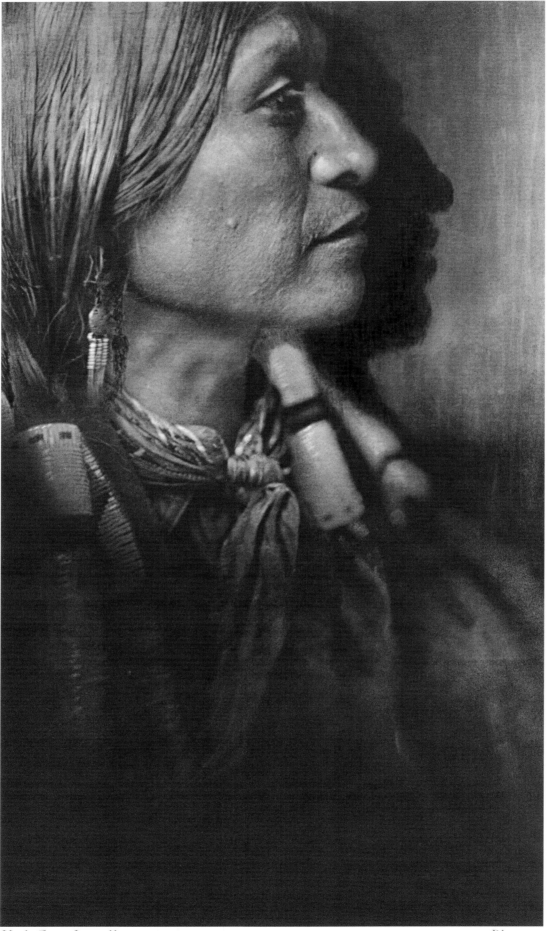

Vash Gon—Jicarilla, 1907 Plate 19

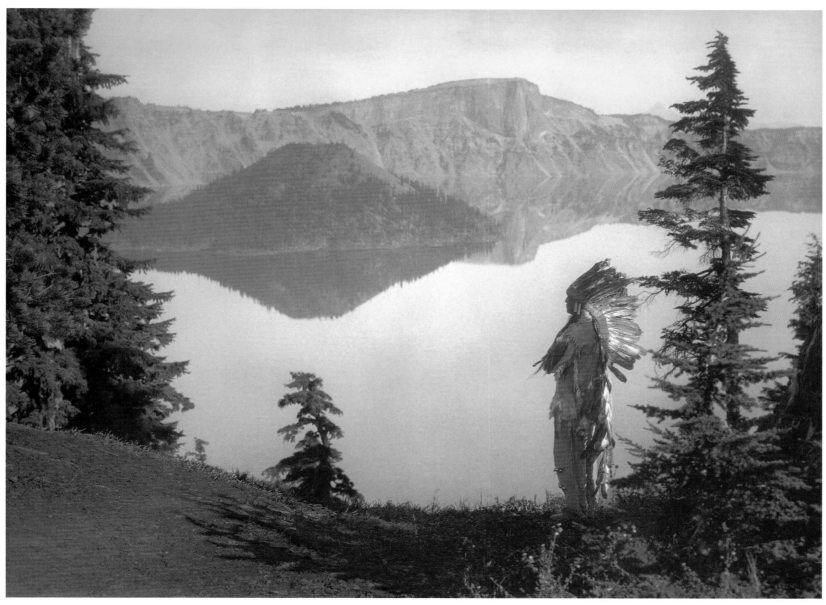

The Chief—Klamath, 1924 Plate 20

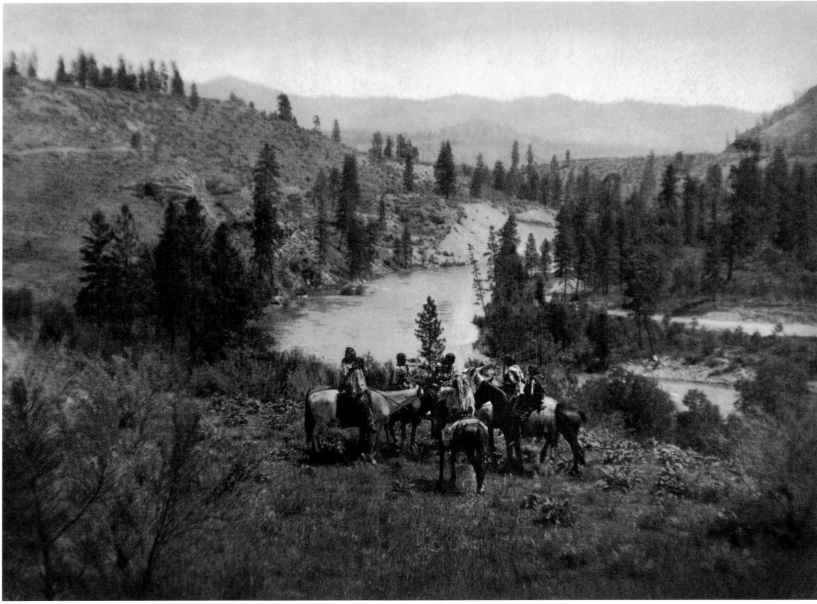

On Spokane River, 1911

Plate 21

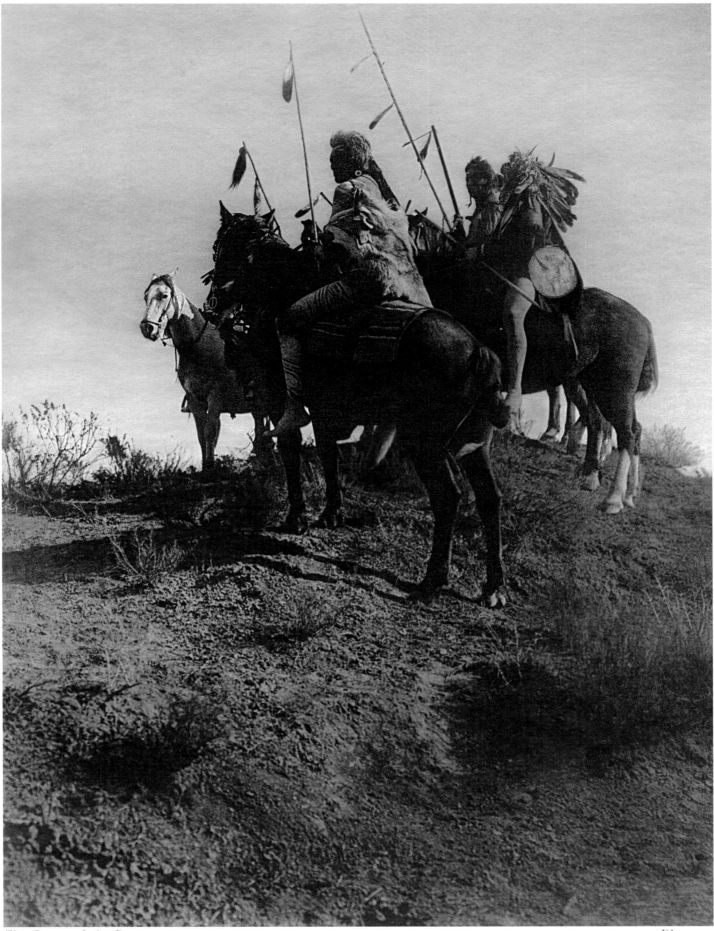

The Spirit of the Past, 1909 Plate 22

Grandfather, Great Spirit, once more behold me on earth and lean to hear my feeble voice. You lived first, and you are older than all need, older than all prayer. All things belong to you—the two-legged, the four-legged, the wings of the air, and all green things that live.

You have set the powers of the four quarters of the earth to cross each other. You have made me cross the good road, and the road of difficulties, and where they cross, the place is holy. Day in, day out, forevermore, you are the life of things.

—Black Elk, Oglala Sioux

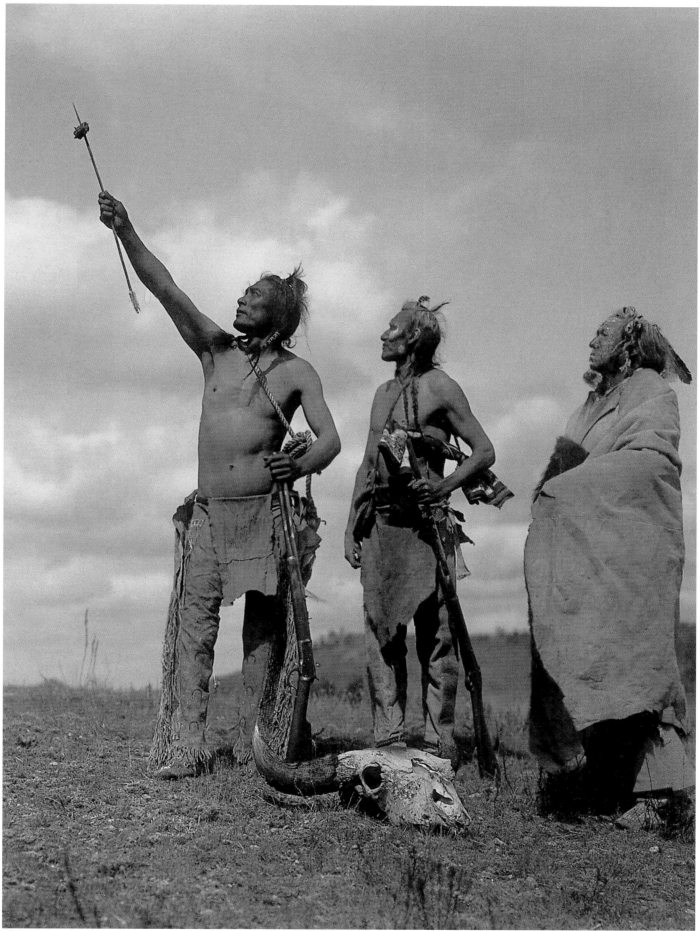

The Oath, Apsaroke, 1909

Plate 23

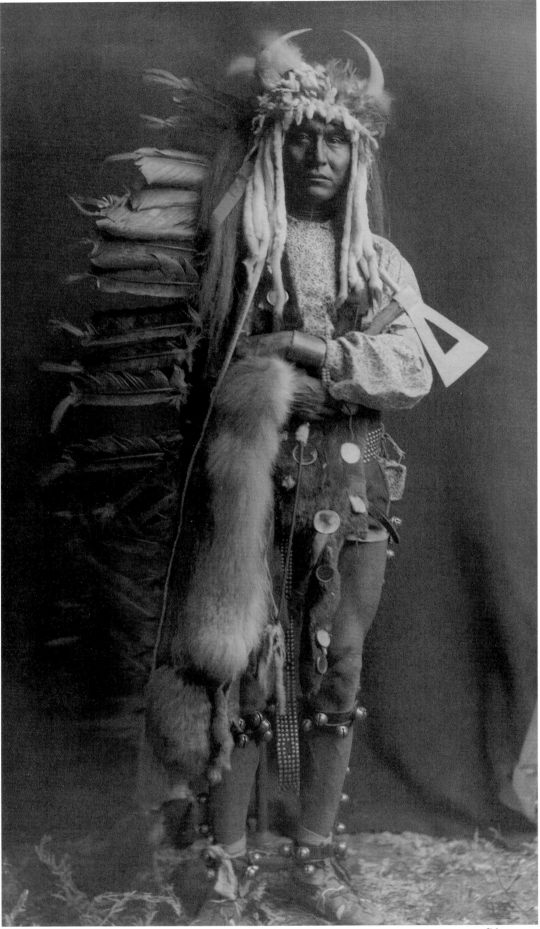

Iron Breast—Piegan, 1911

Plate 24

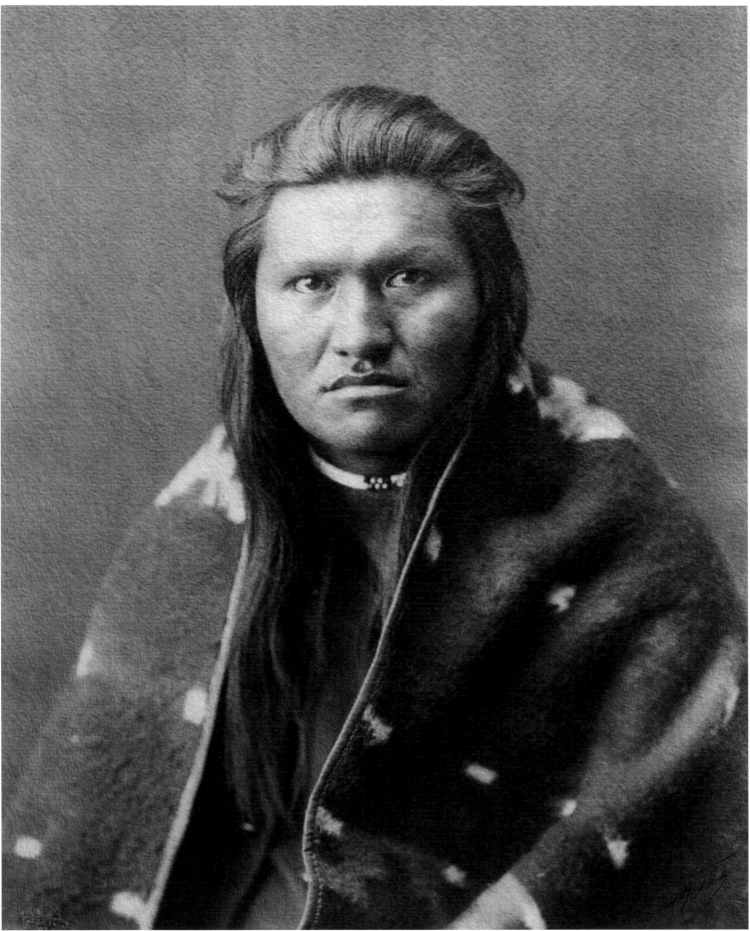

Untitled (Nez Percé Brave, 1899) Plate 25

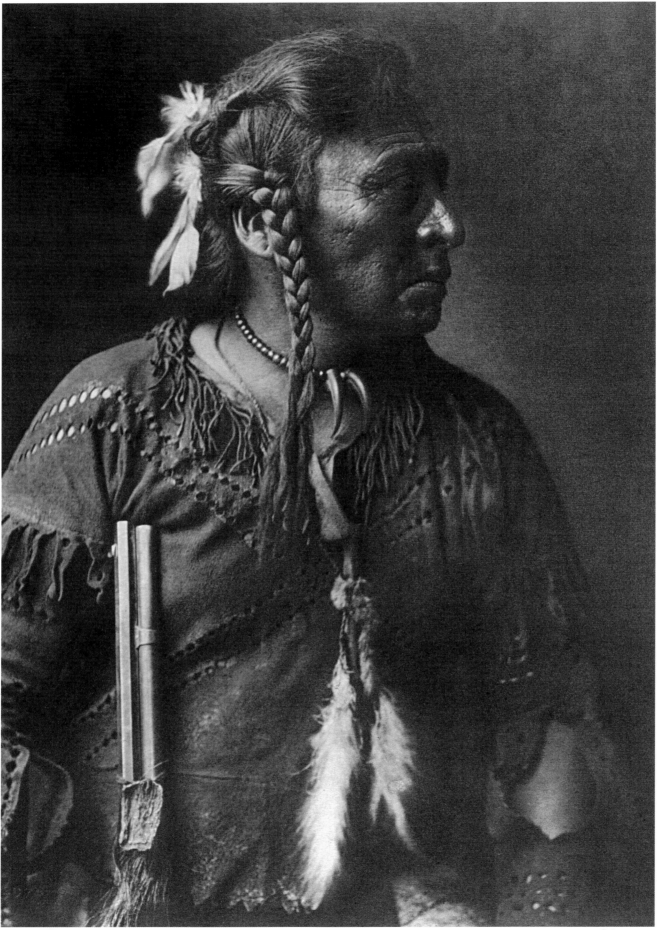

Horse Capture—Atsina, 1909 Plate 26

NORTHWEST NATIVE EXPRESSIONS

LOCATED AT THE JAMESTOWN S'KLALLAM TRIBAL CENTER

Open 9 to 5 Daily

NATIVE ART GALLERY

1033 Old Blyn Highway
Sequim, WA 98382
(360) 681-4640
Fax (360) 681-4649

email: gallery@jamestowntribe.org
www.NorthwestNativeExpressions.com

www.NorthwestNativeExpressions.com

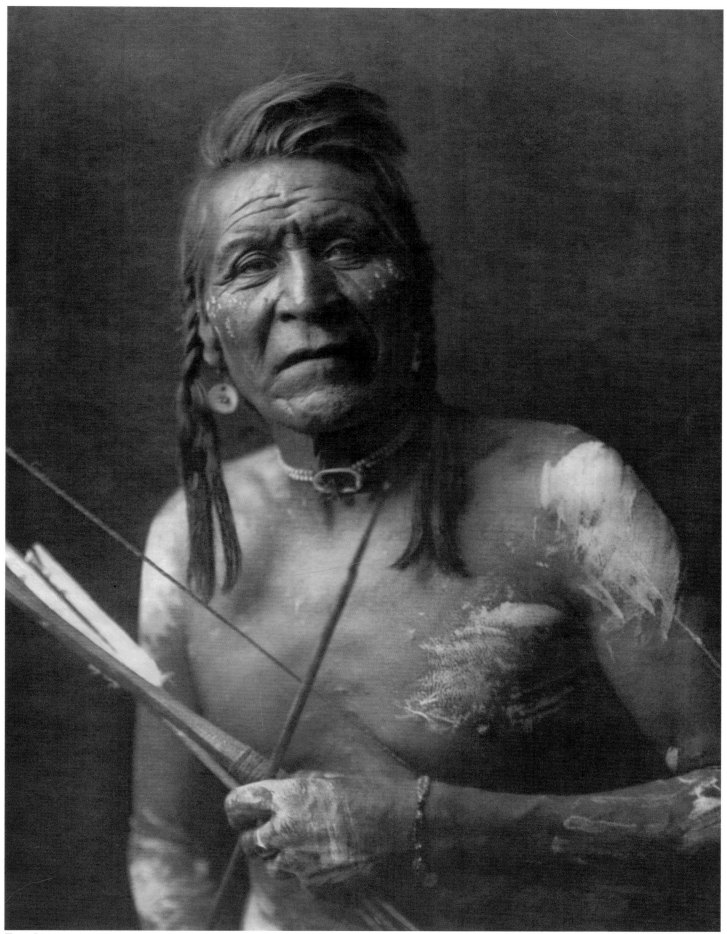

Two Leggings—Apsaroke, 1909 Plate 27

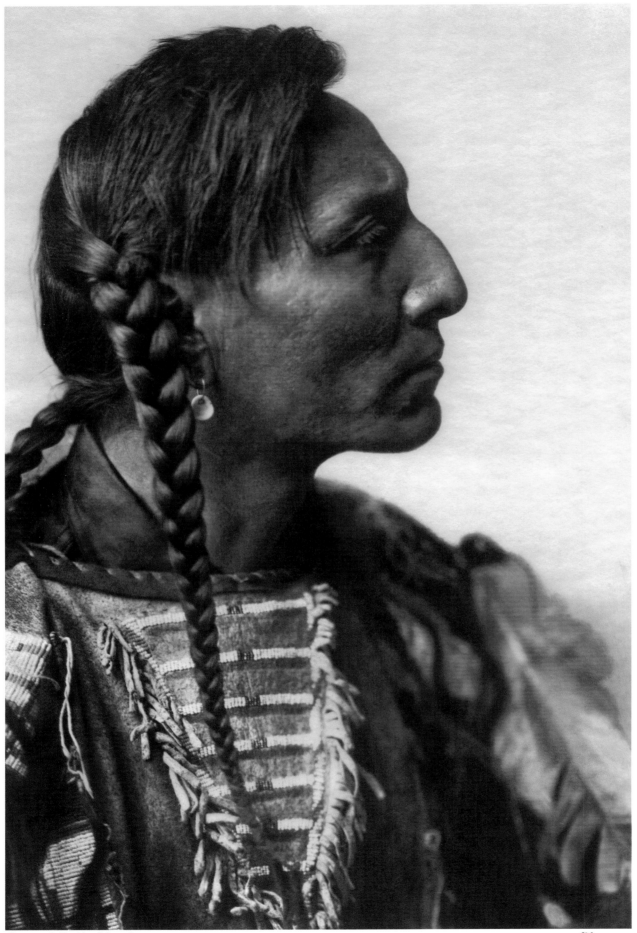

Spotted Bull—Mandan, 1909 Plate 28

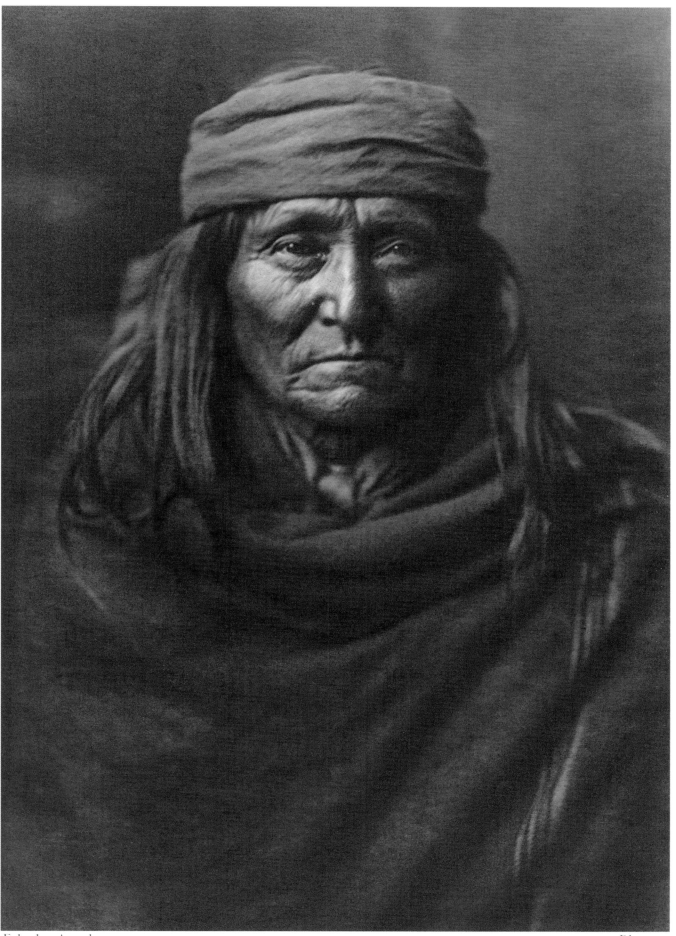

Eskadi—Apache, 1907 Plate 29

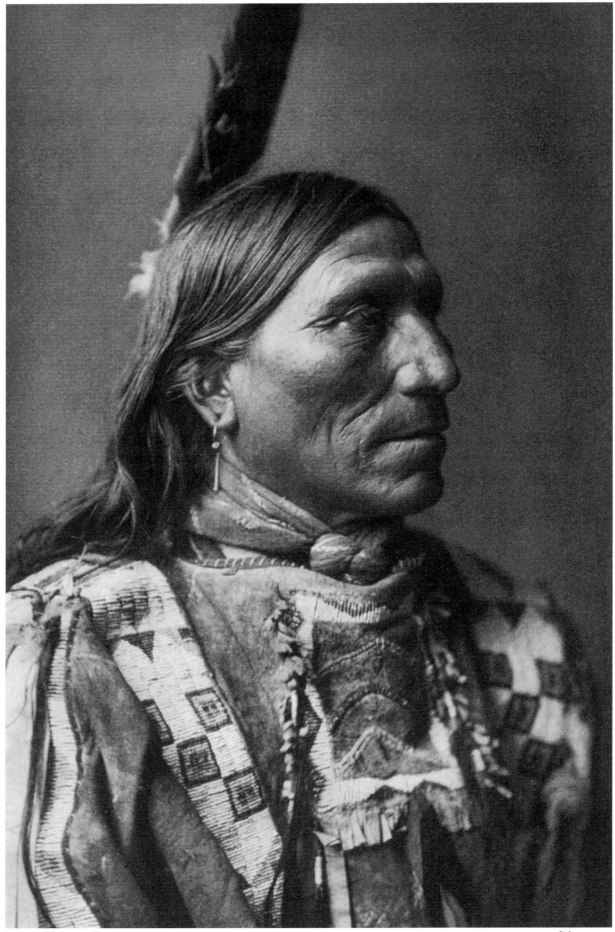

Little Hawk—Brulé, 1908

Plate 30

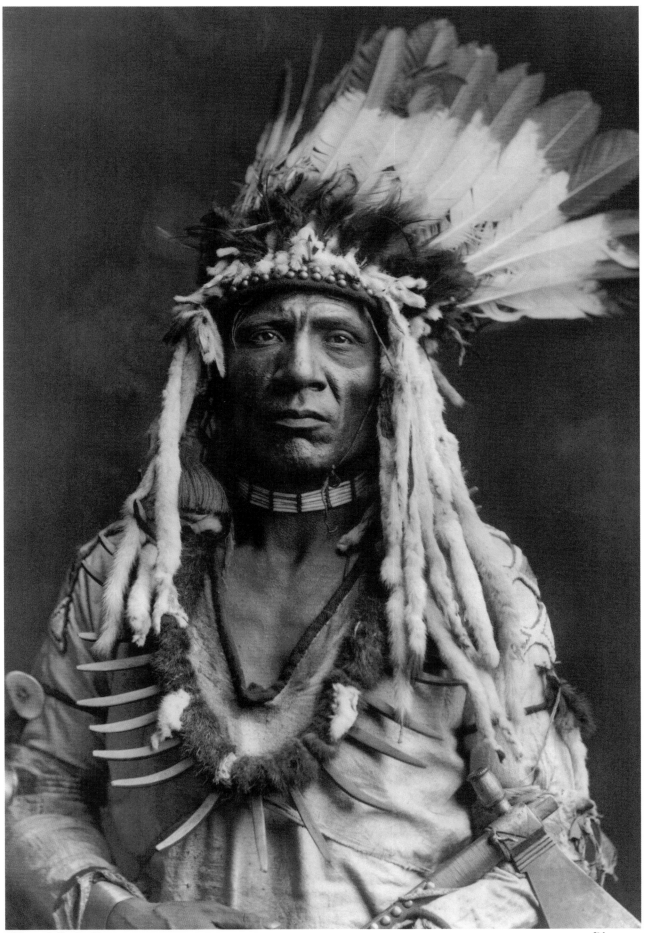

Weasel Tail—Piegan, 1911 Plate 31

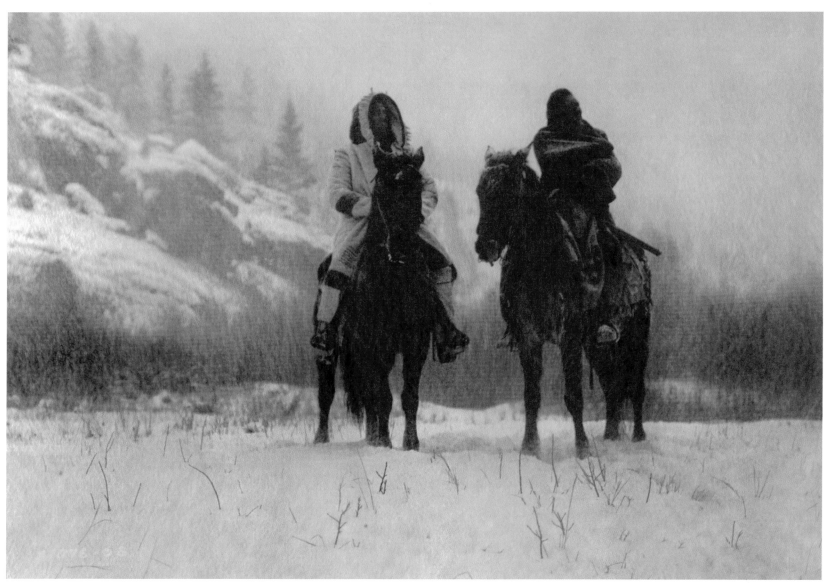

For a Winter Campaign—Apsaroke, 1909

Plate 32

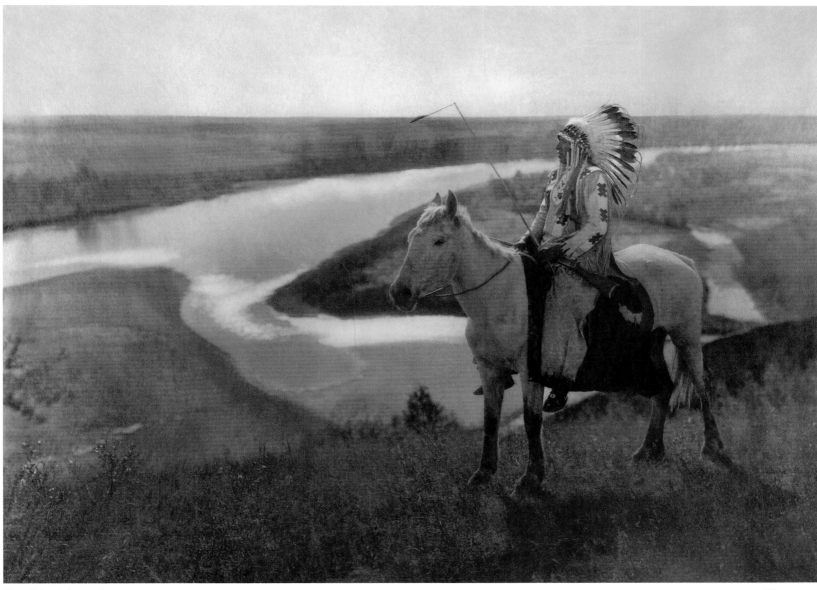

The Blackfoot Country, 1928

Plate 33

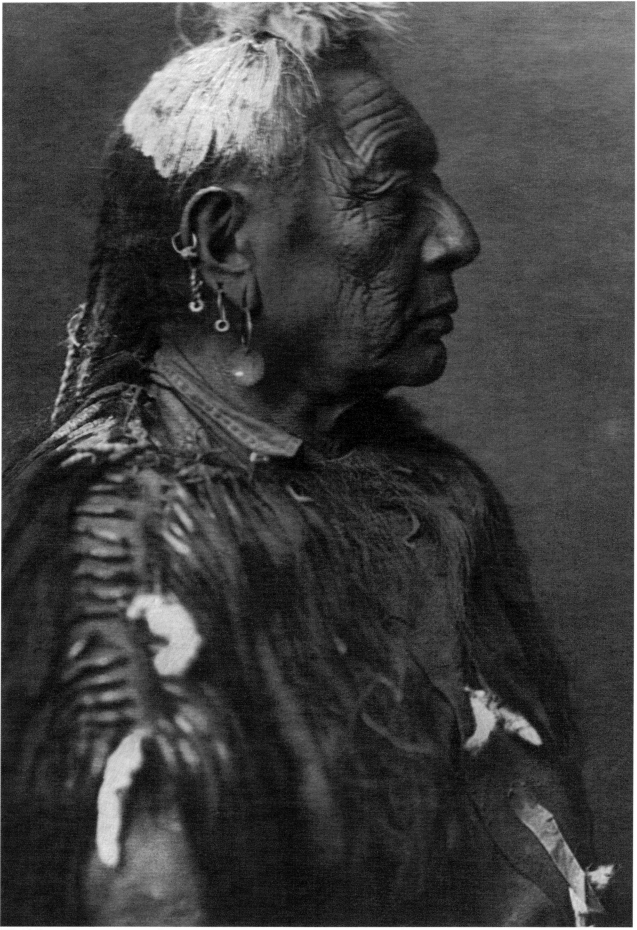

Wolf Lies Down—Apsaroke, 1909 Plate 34

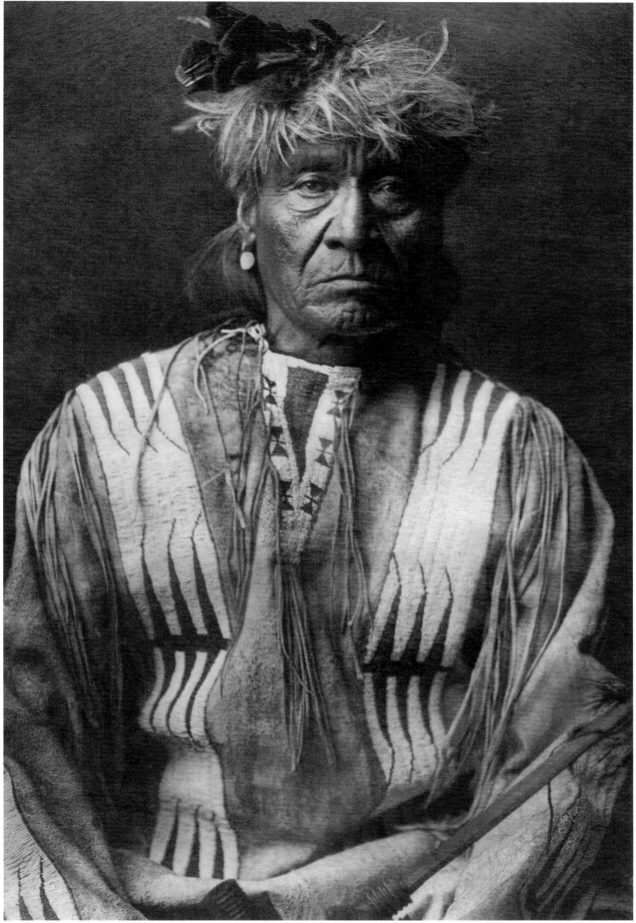

Red Whip—Atsina, 1909

Plate 35

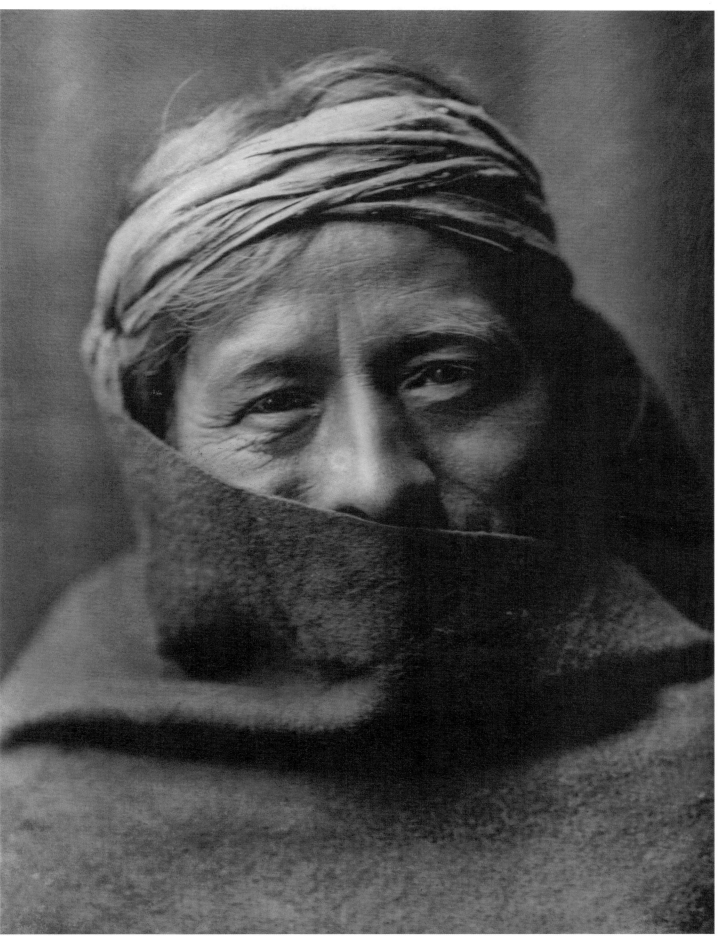

Waihusiwa—A Zuni Kyáqimássi, 1926 Plate 36

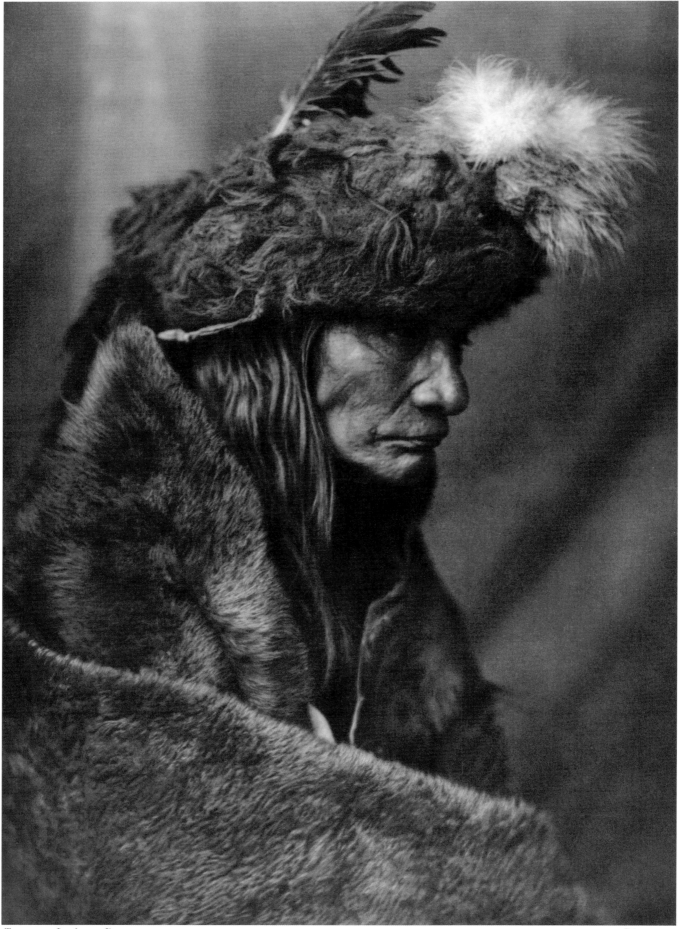

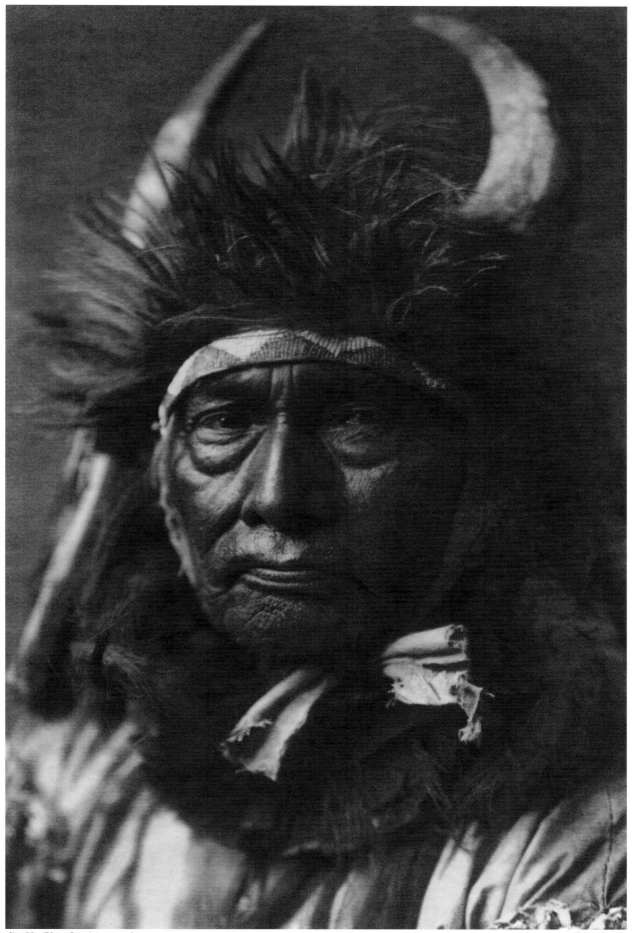

Bull Chief—Apsaroke, 1909 Plate 38

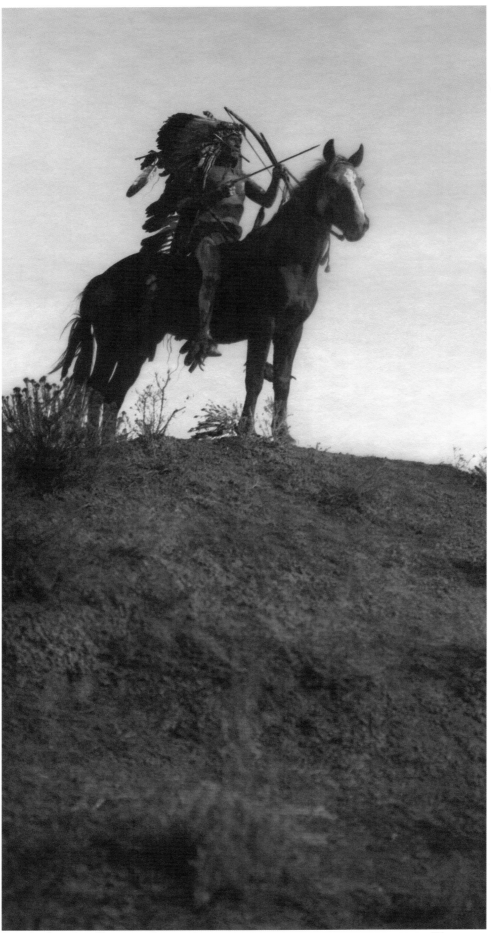

Ready for the Charge—Apsaroke, 1909 Plate 39

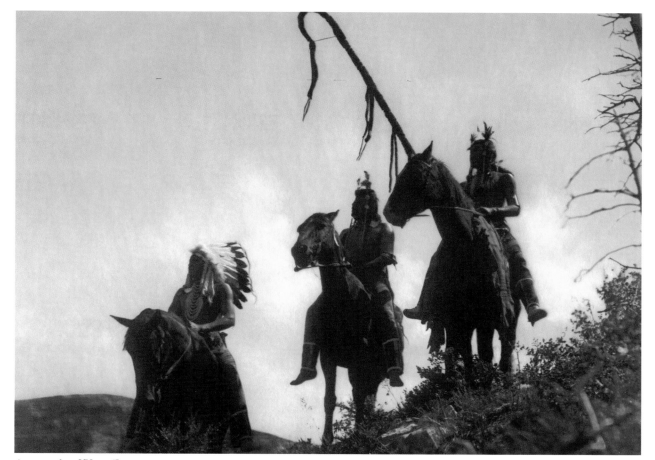

Apsaroke War Group, 1909 Plate 40

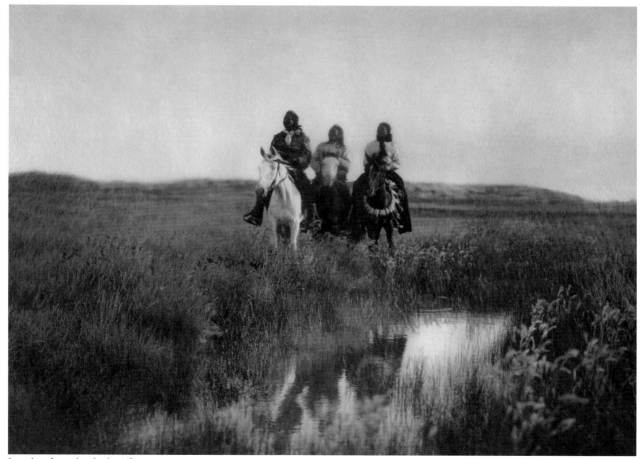

In the Land of the Sioux, 1908 Plate 41

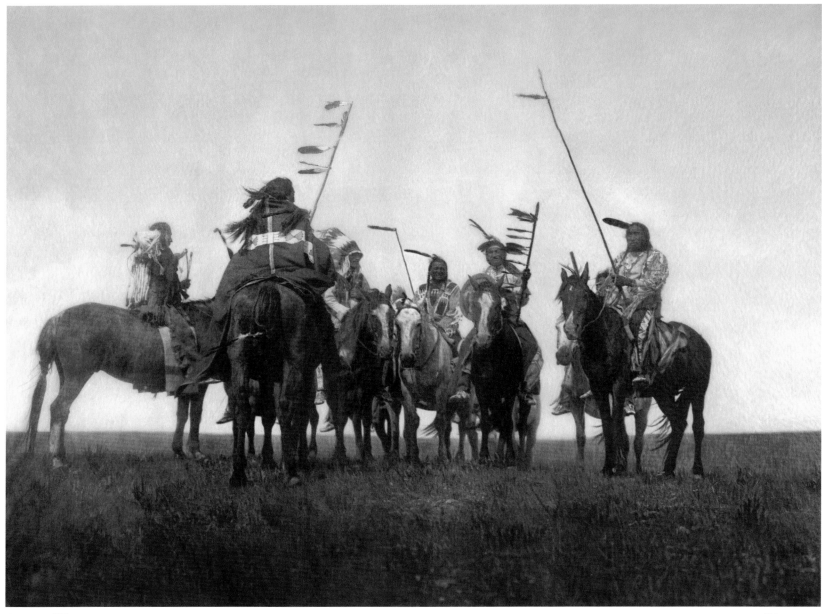

Atsina Warriors, 1909 Plate 42

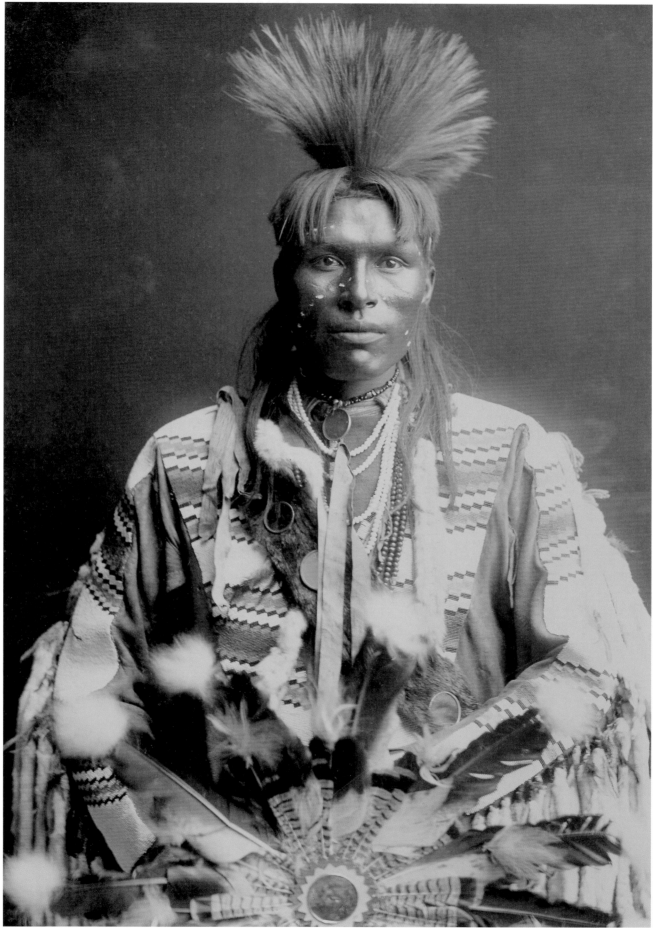

A Piegan Dandy, 1911

Plate 43

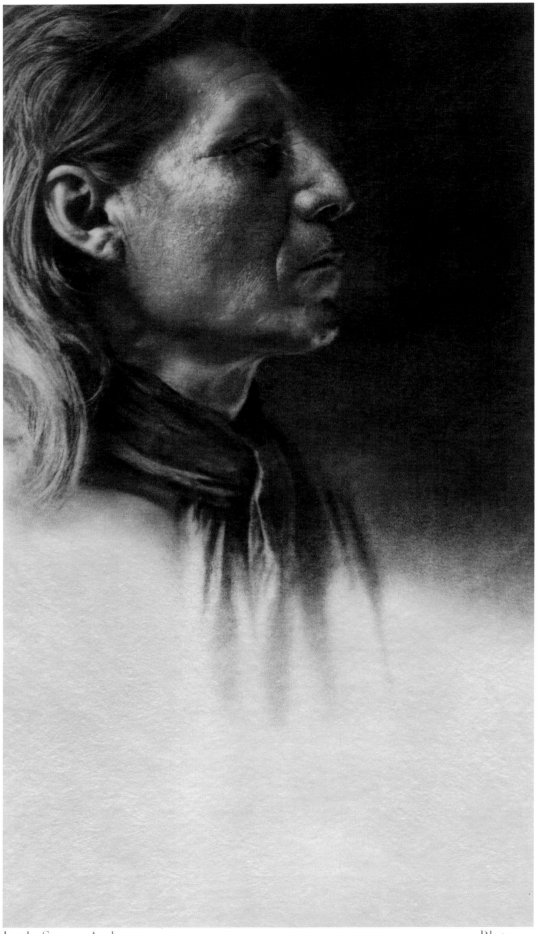

Plate 44

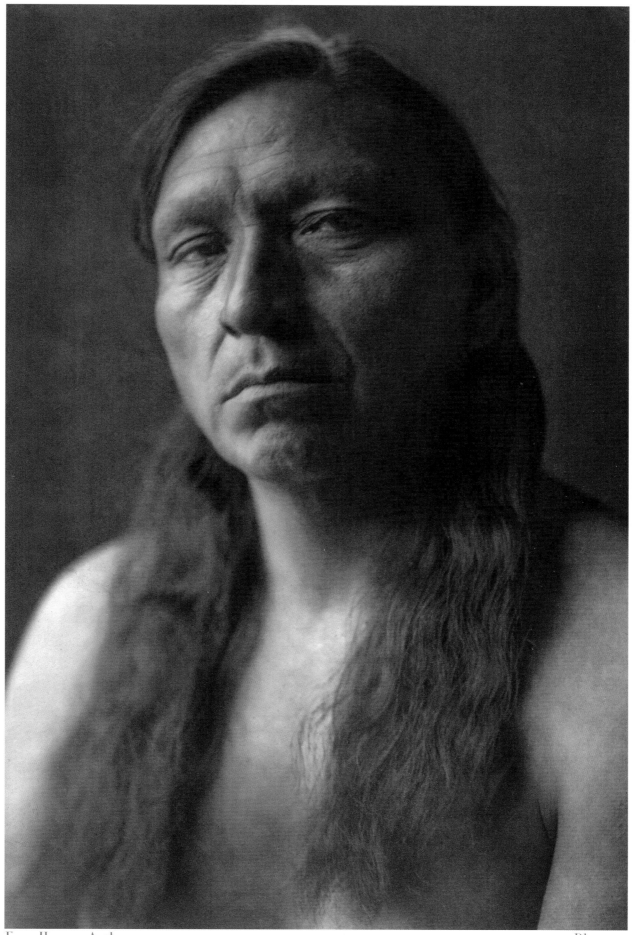

Four Horns—Arikara, 1909

Plate 45

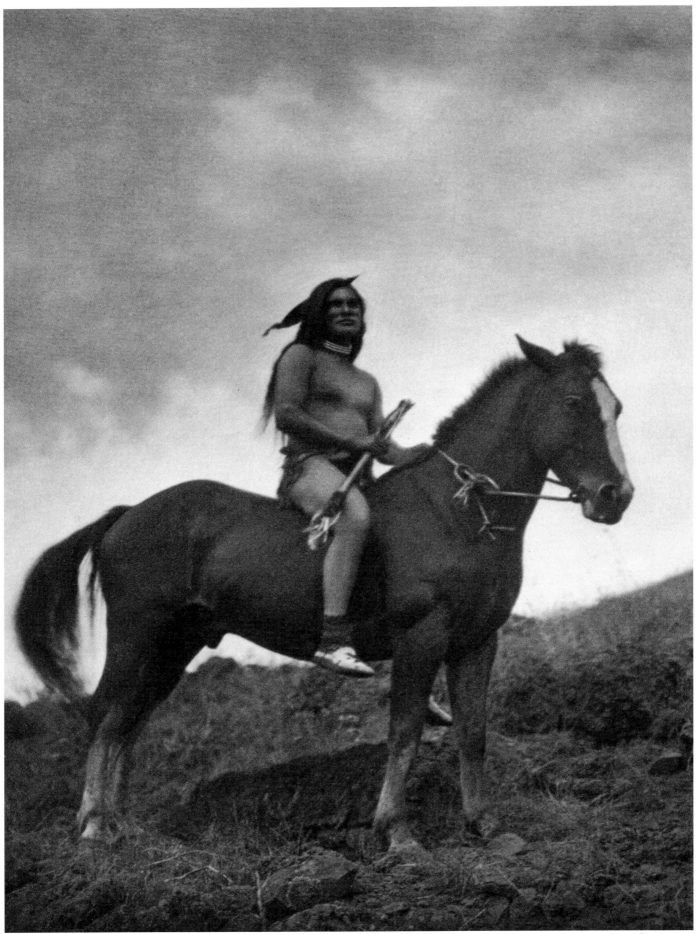

The Old Time Warrior—Nez Percé, 1911

Plate 46

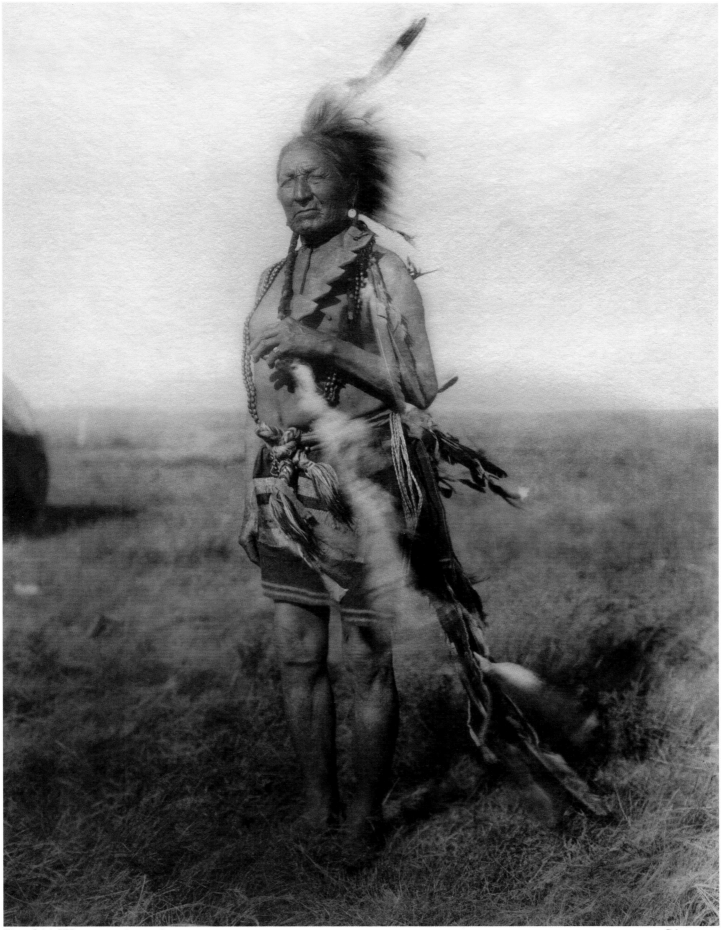

The Old Warrior—Arapaho, 1930

Plate 47

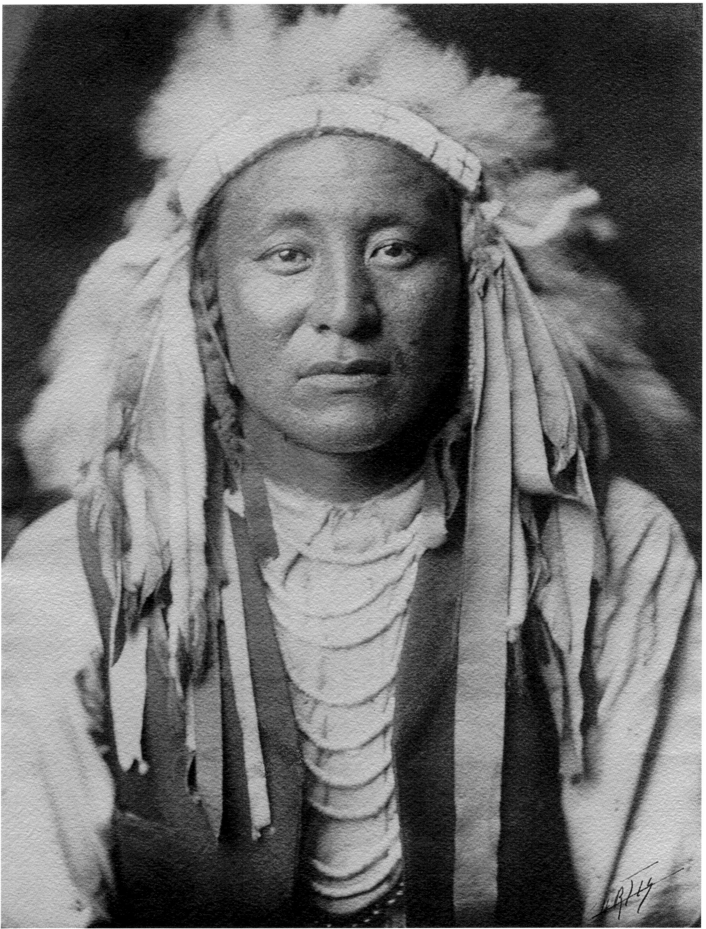

Untitled (Northern Plains Male) Plate 48

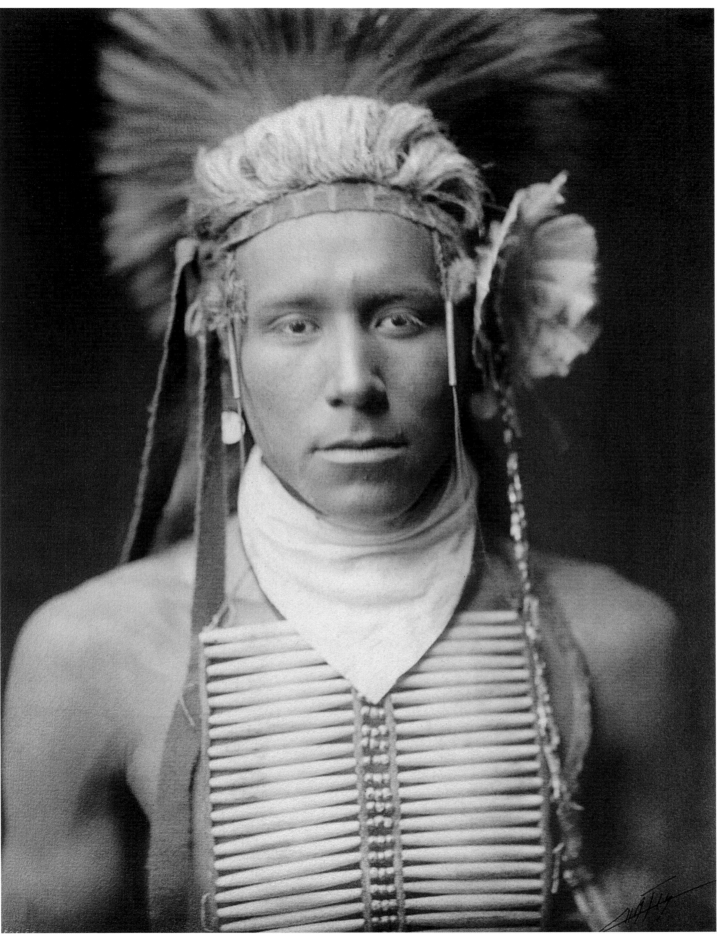

Untitled (Male with Breastplate) Plate 49

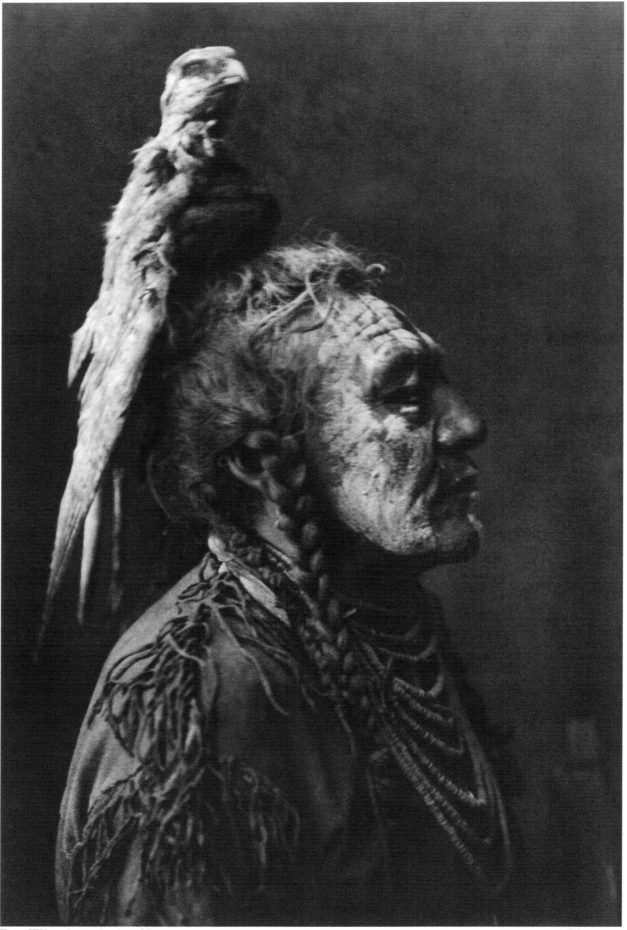

Two Whistles—Apsaroke, 1909 Plate 50

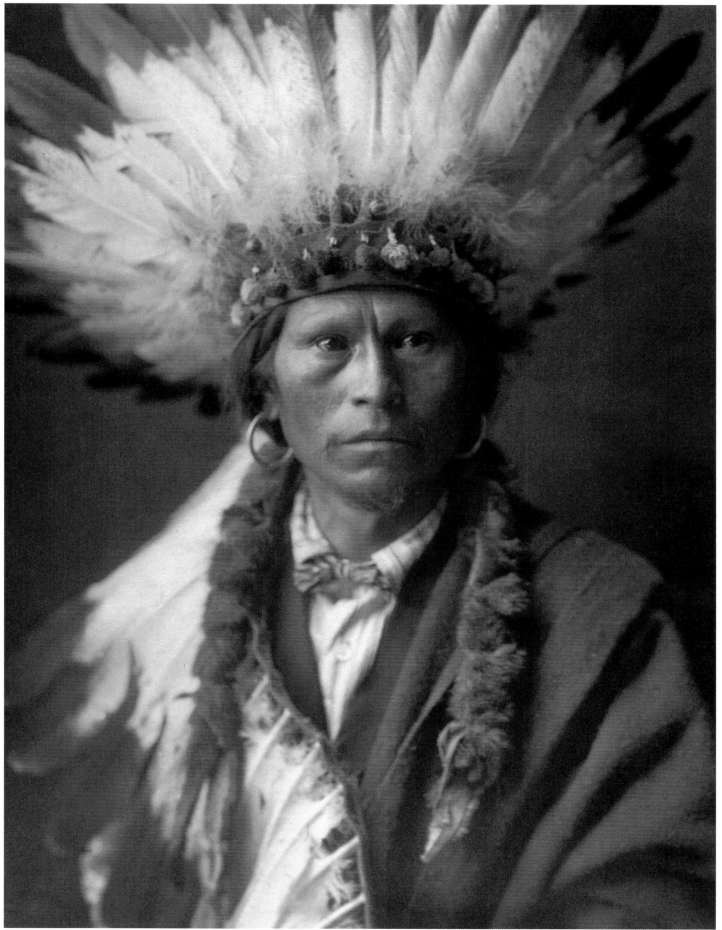

Chief Garfield—Jicarilla, 1907 Plate 51

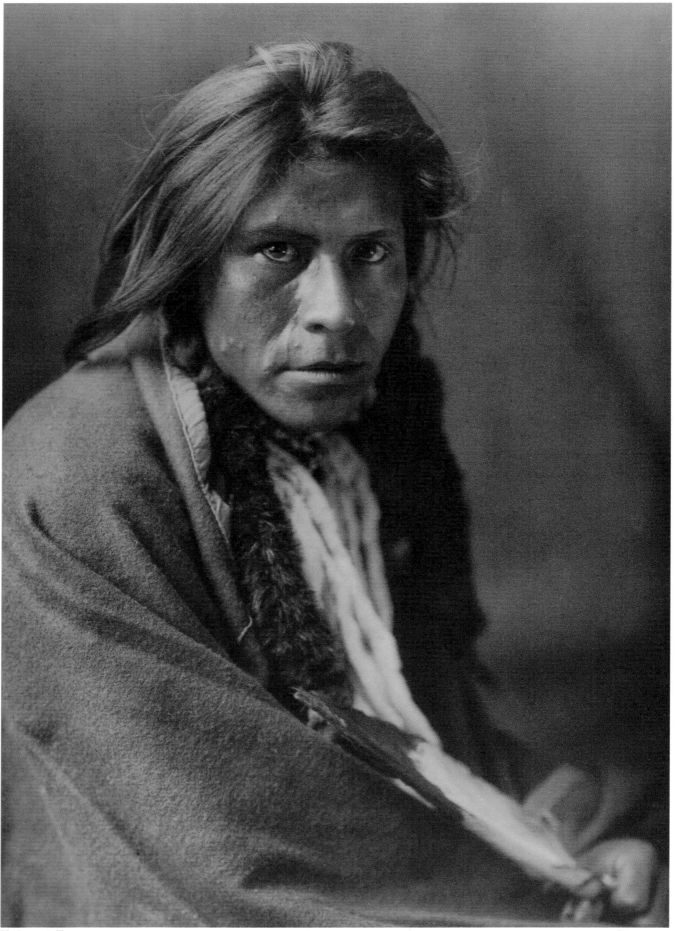

Plate 52

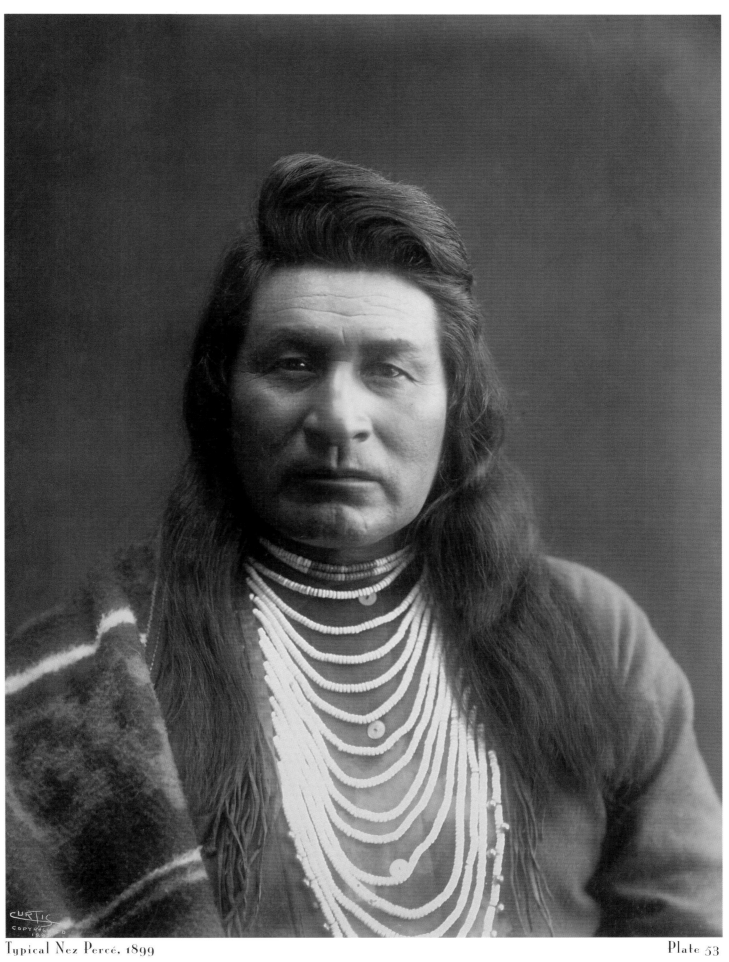

Typical Nez Percé, 1899

Plate 53

If all would talk and then do as you have done, the sun of peace would shine forever.

—Satank, Kiowa

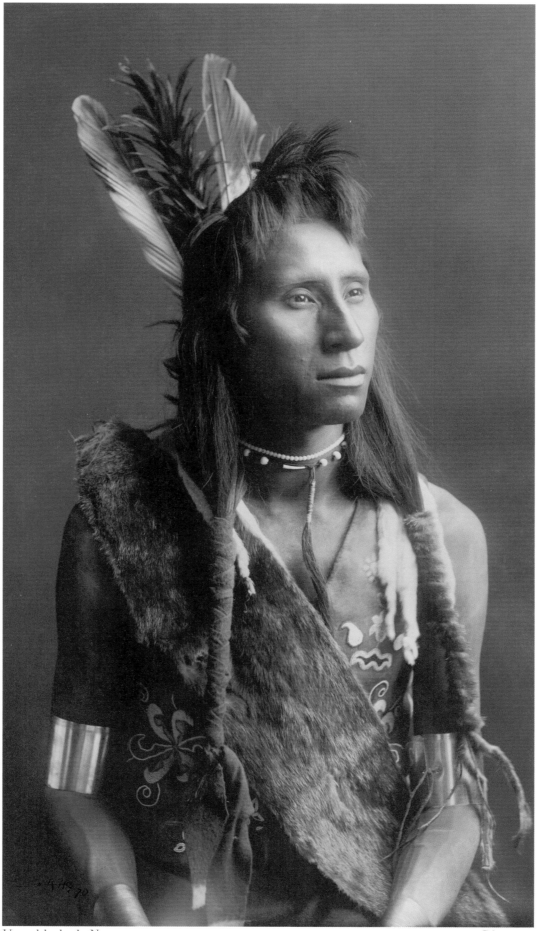

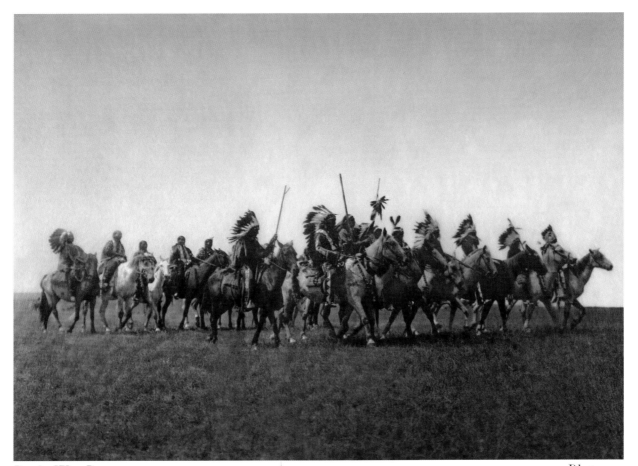

Brulé War Party, 1908 Plate 55

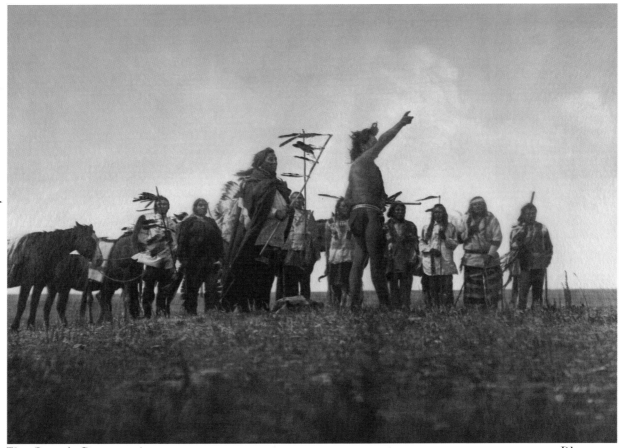

The Scout's Report—Atsina, 1909 Plate 56

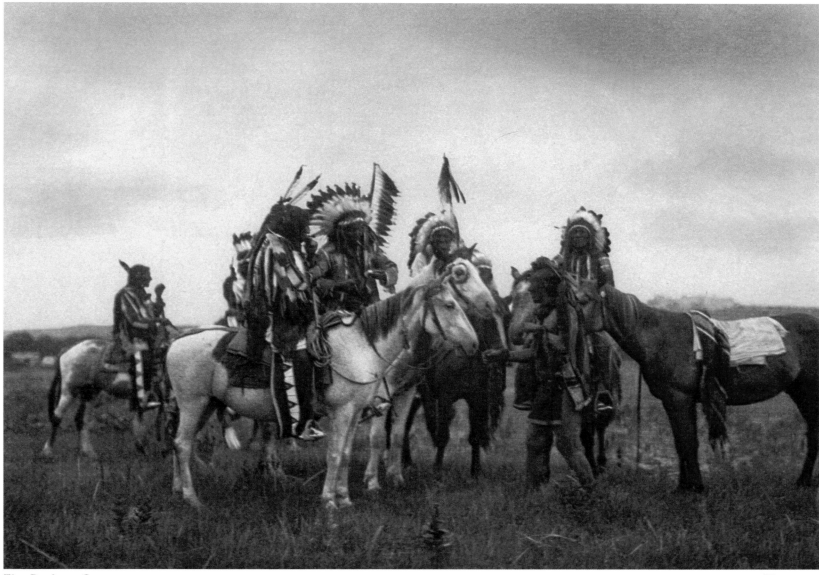

The Parley—Sioux, 1908 Plate 57

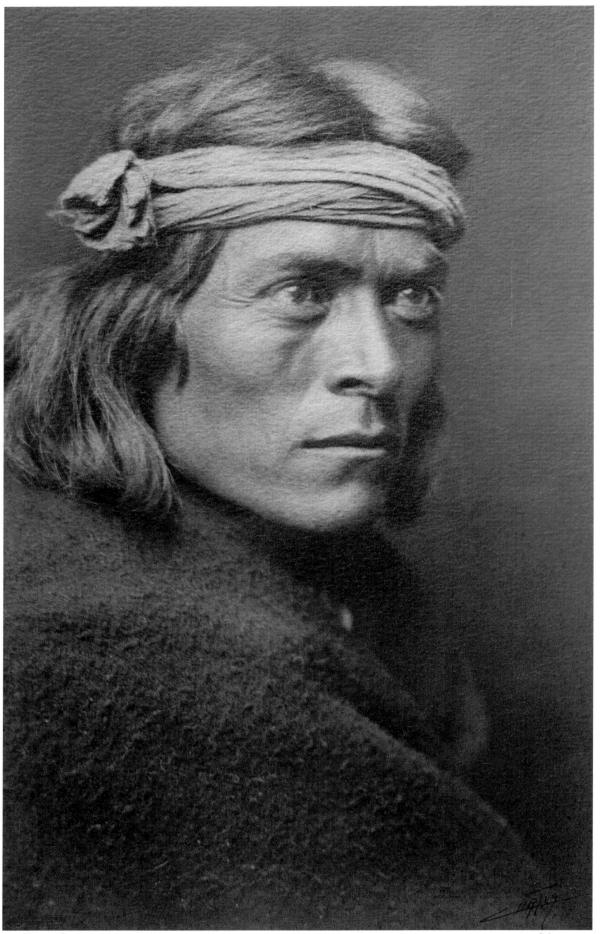

A Zuni Governor, 1926 Plate 58

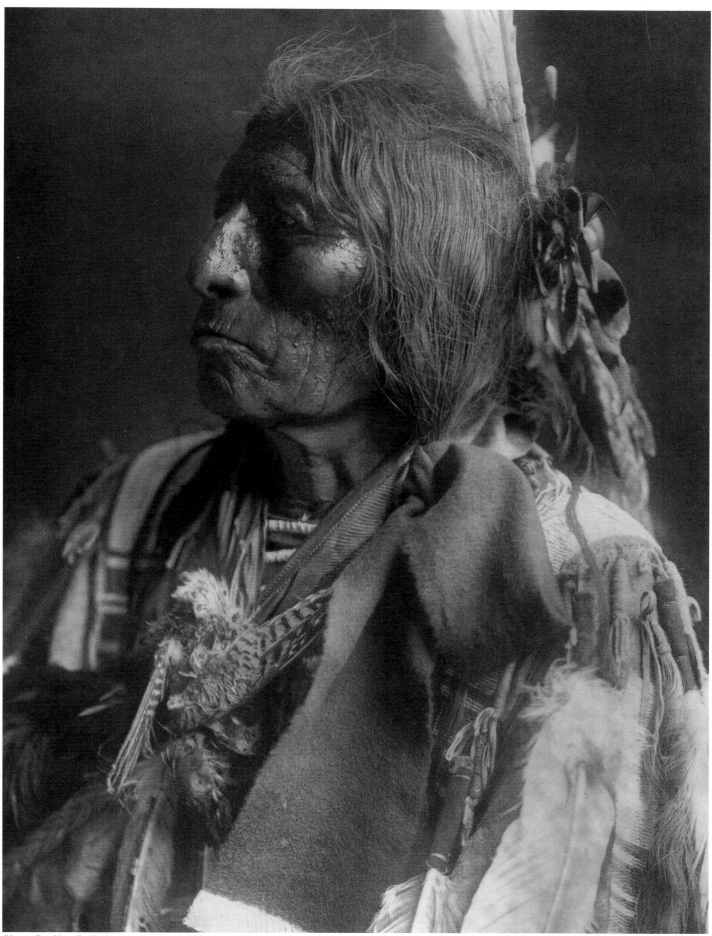

Slow Bull—Oglala, 1908

Plate 59

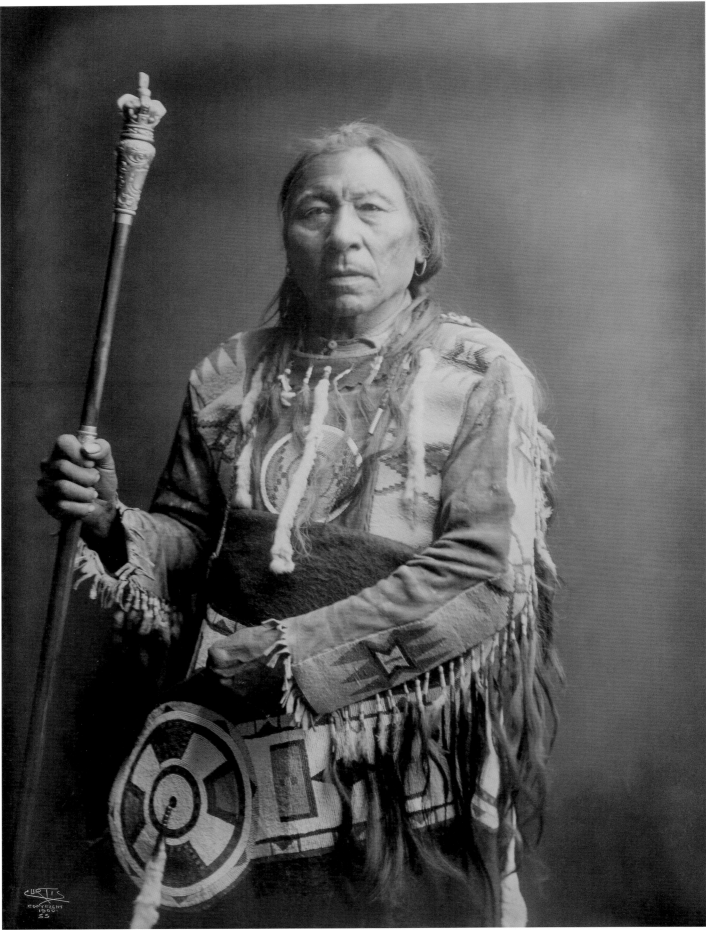

Untitled (Piegan)

Plate 60

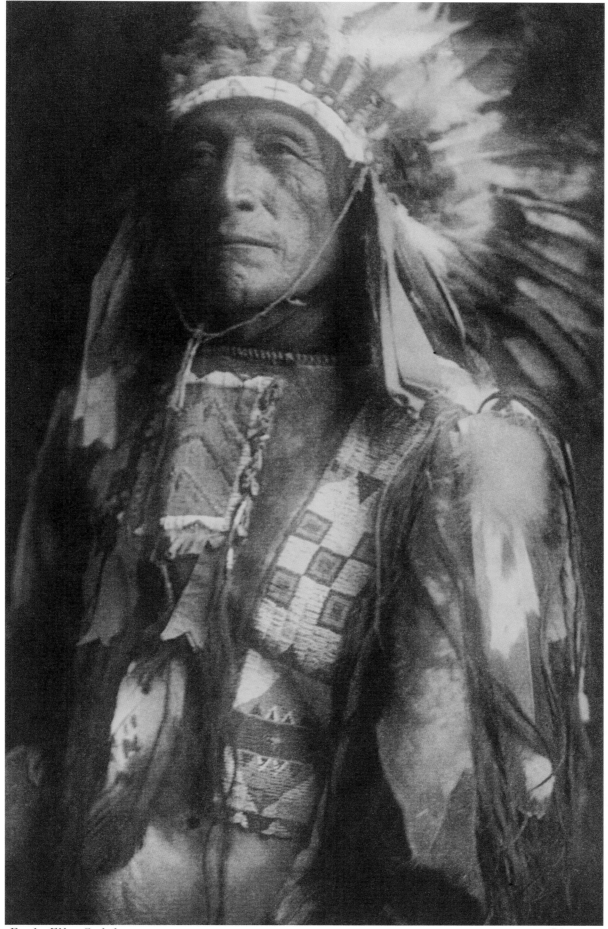

Eagle Elk—Oglala, 1908 Plate 61

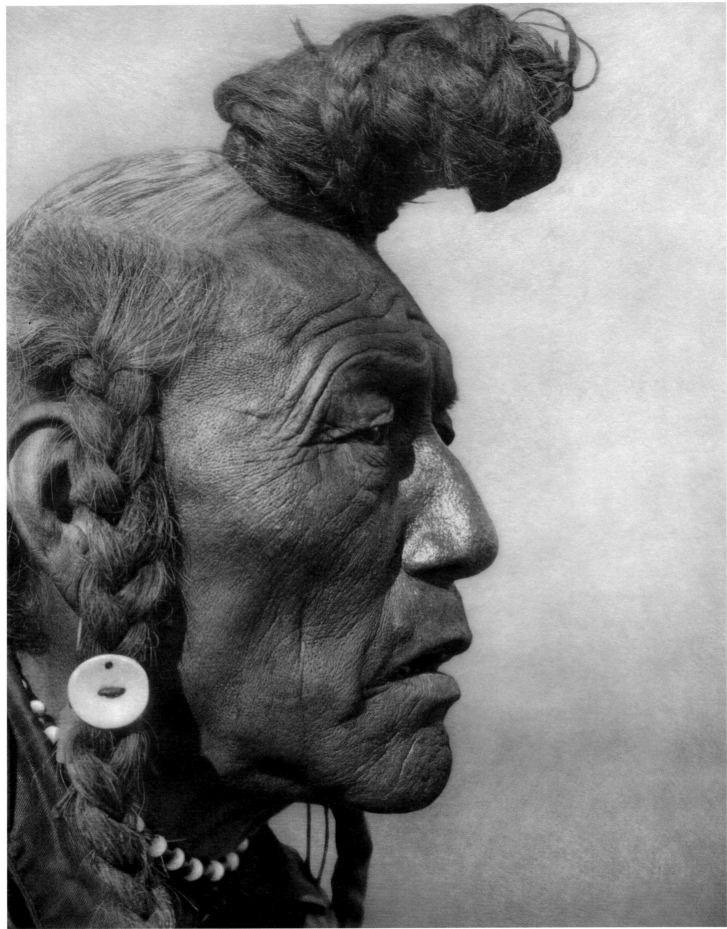

Bear Bull—Blackfoot, 1928 Plate 62

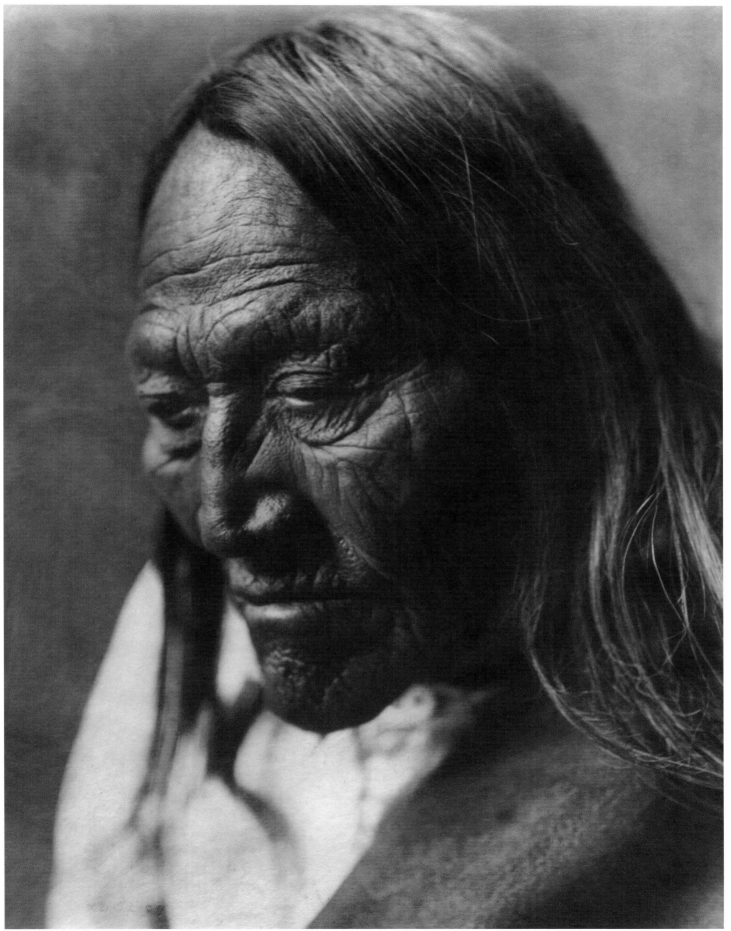

Two Strike—Brulé-Sioux, 1908

Plate 63

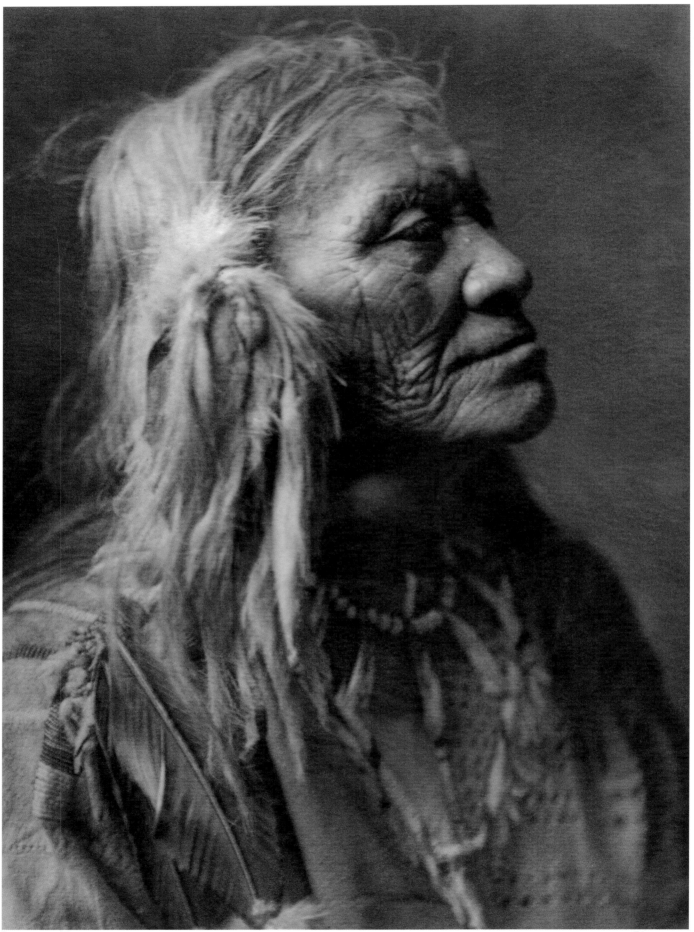

Luqaîôt—Kittitas, 1911 Plate 64

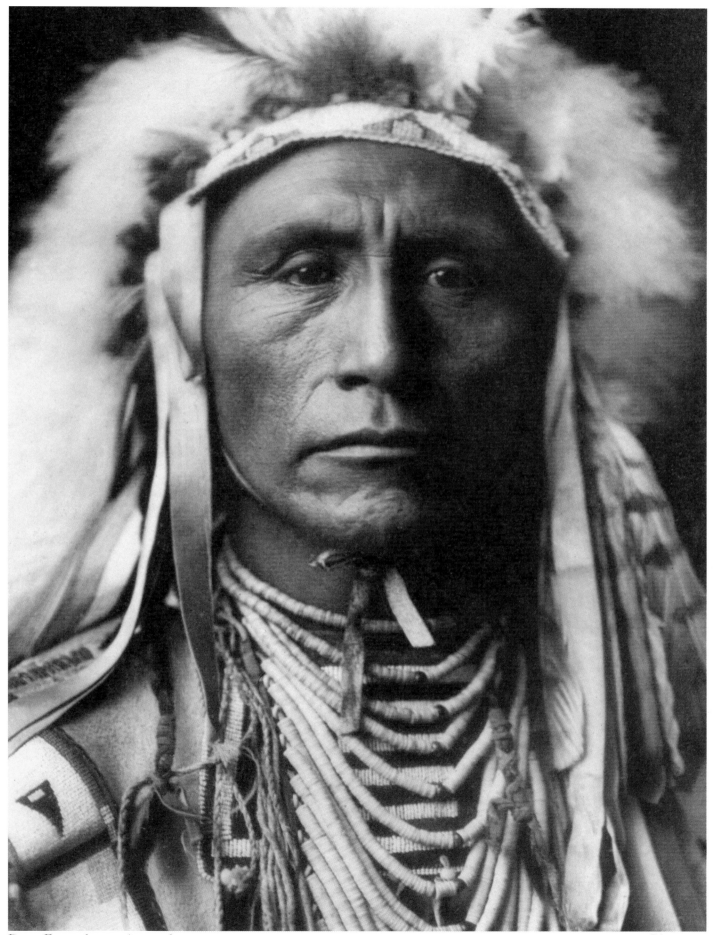

Does Everything—Apsaroke, 1909

Plate 65

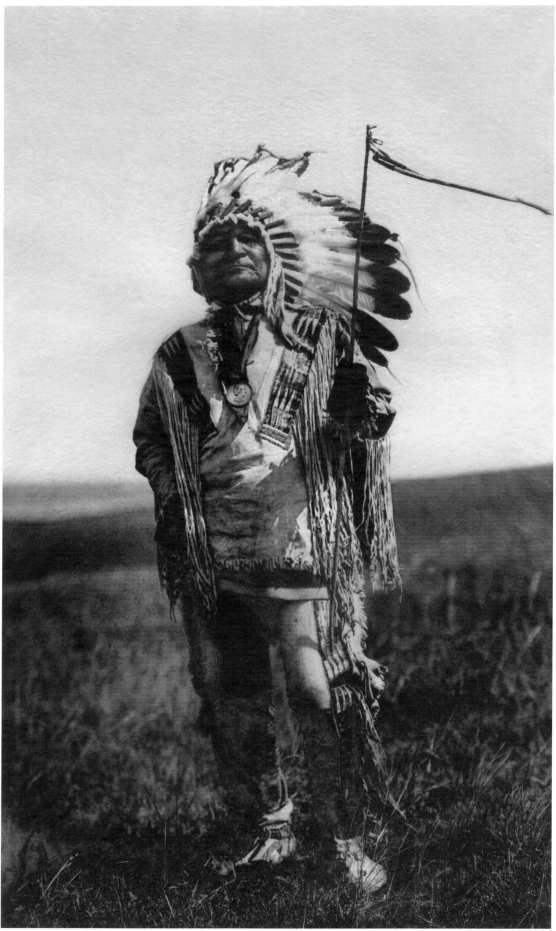

Arikara Chief, 1909 Plate 68

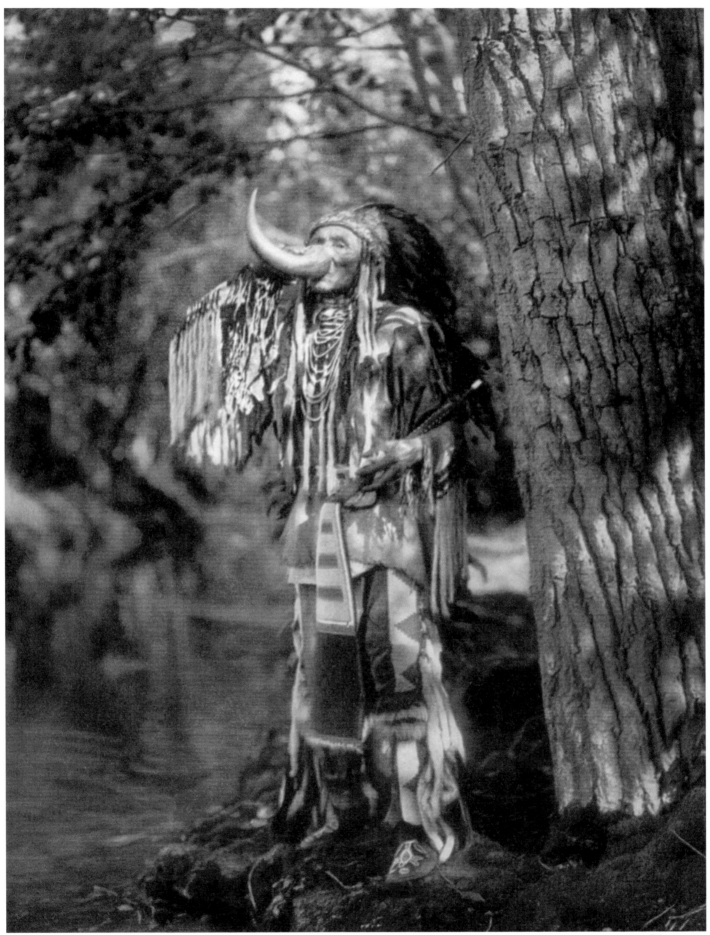

Flathead Warrior, 1911

Plate 69

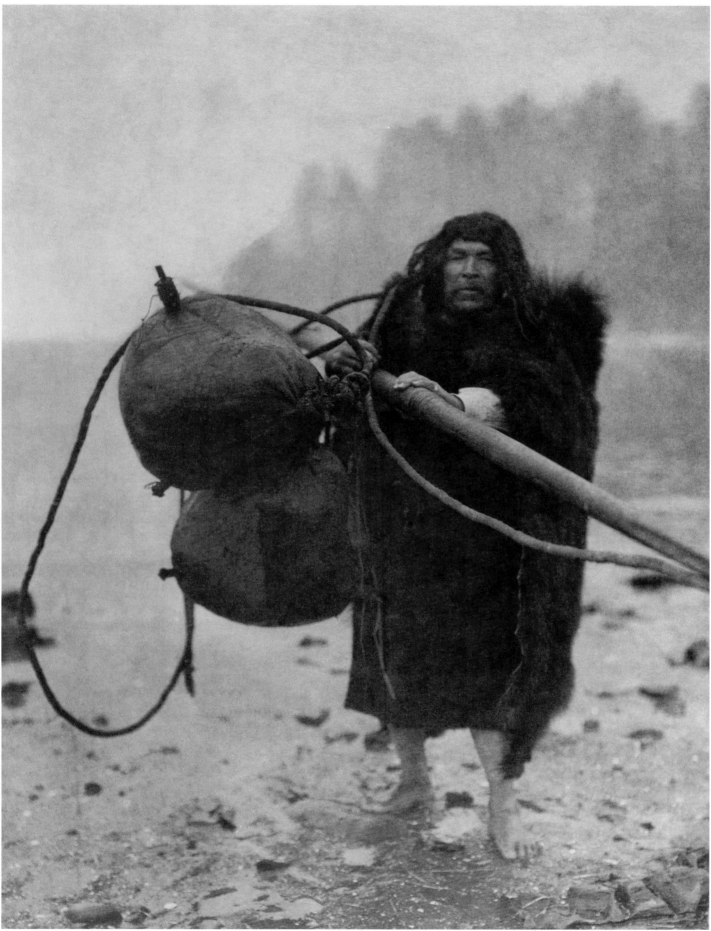

The Whaler—Makah, 1916

Plate 70

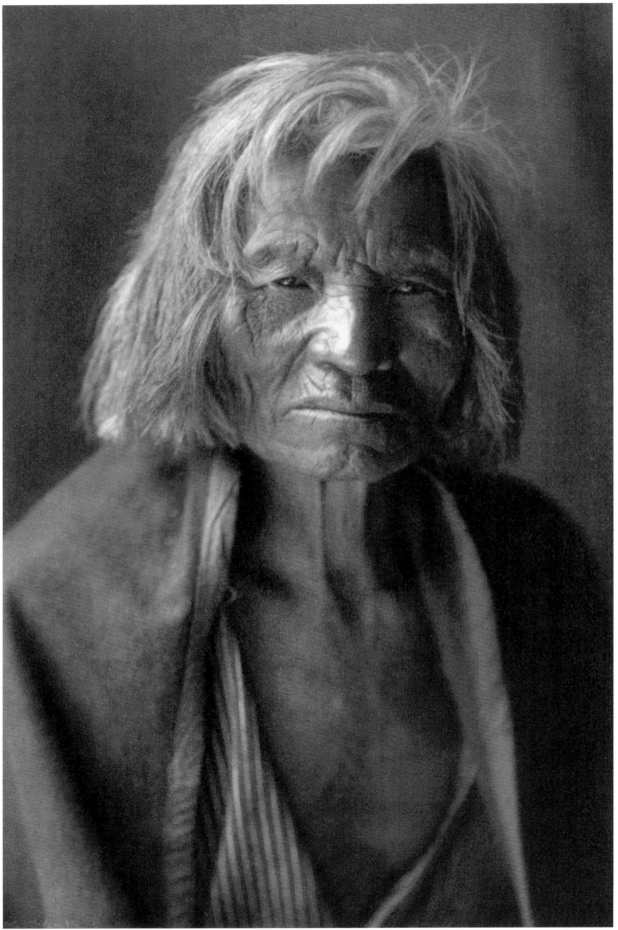

Masselow—Kalispel Chief, 1911 Plate 71

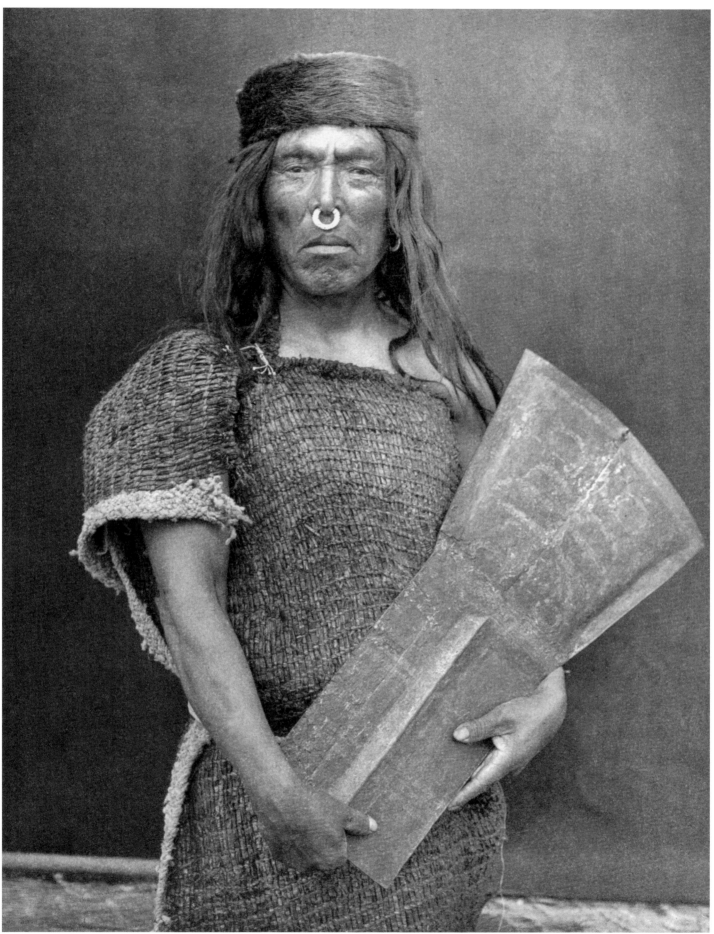

Nakoatok Chief and Copper, 1915

Plate 72

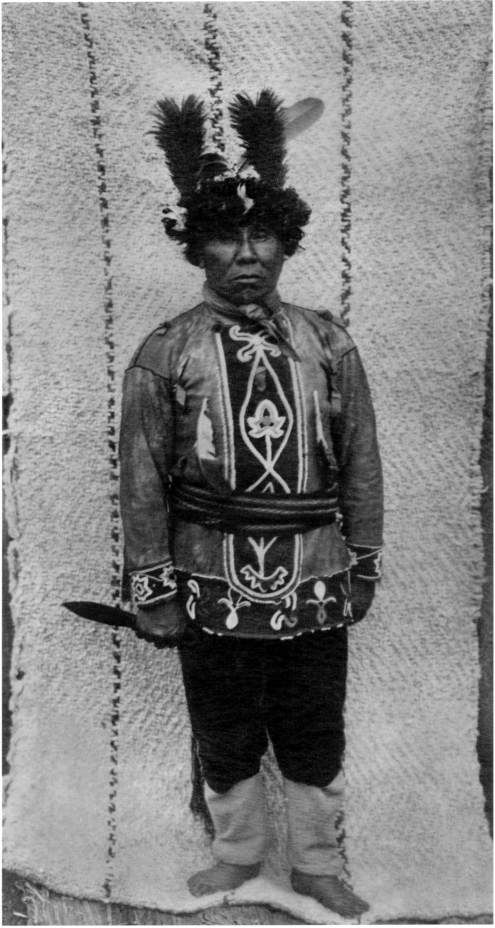

Cowichan Warrior, 1913 Plate 73

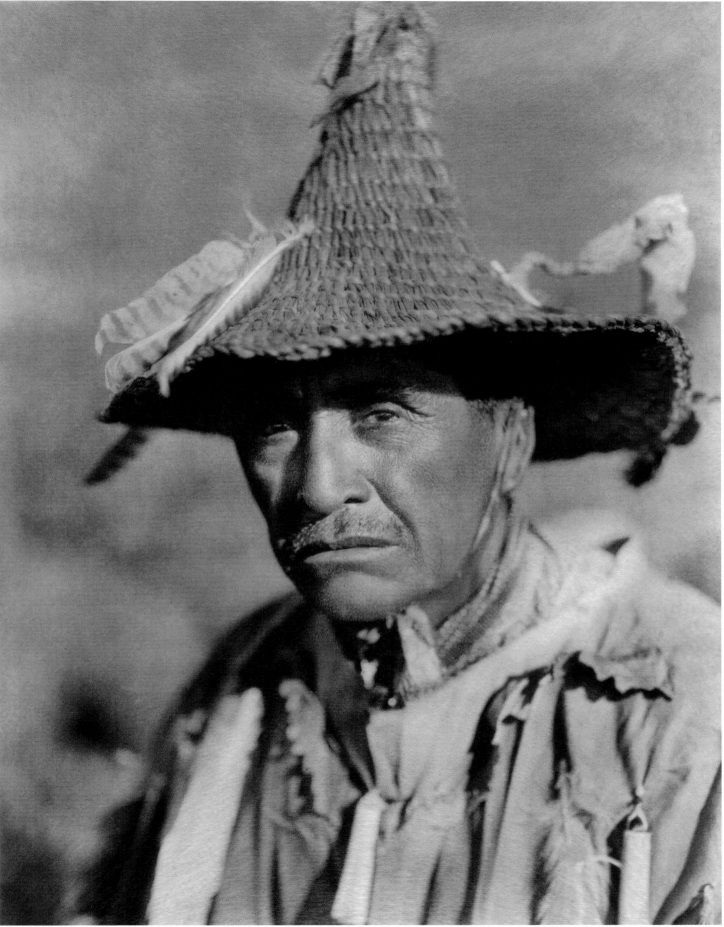

Klamath Warrior's Headdress, 1924 Plate 74

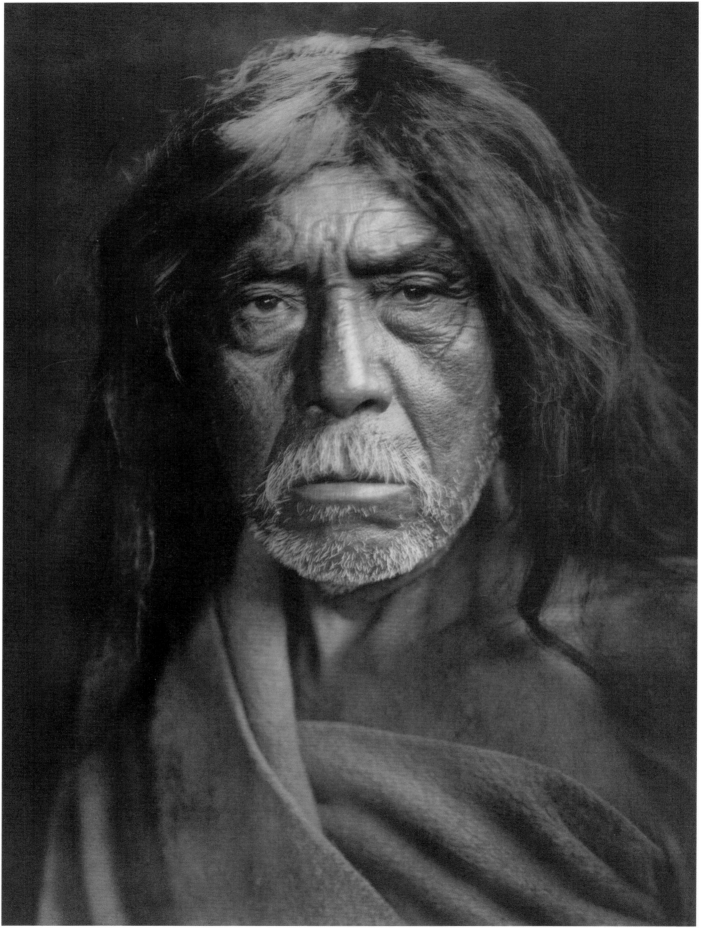

Siwat—Awaitlala, 1915 Plate 75

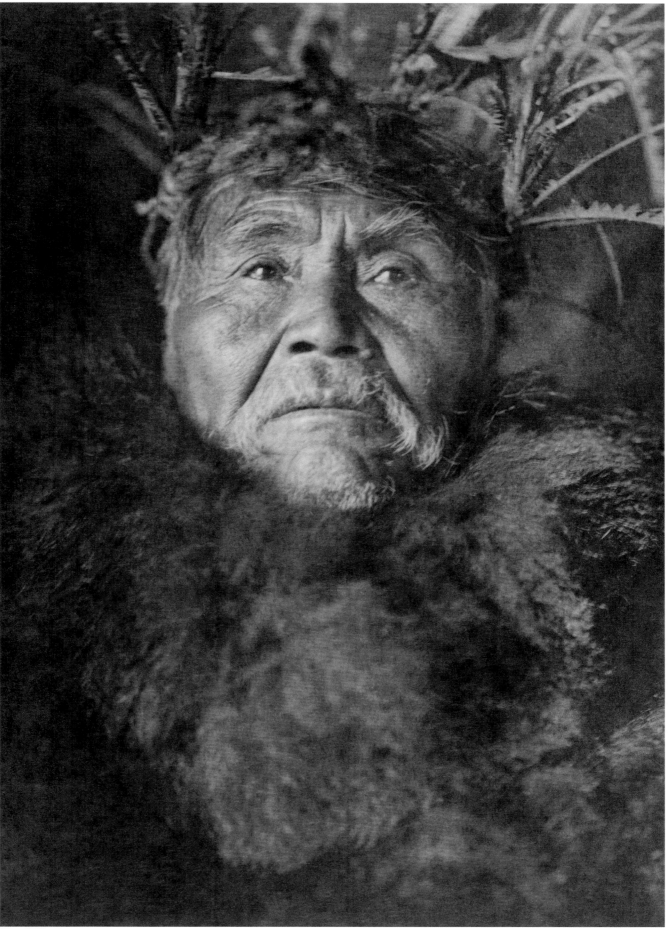

The Whaler, 1916 Plate 76

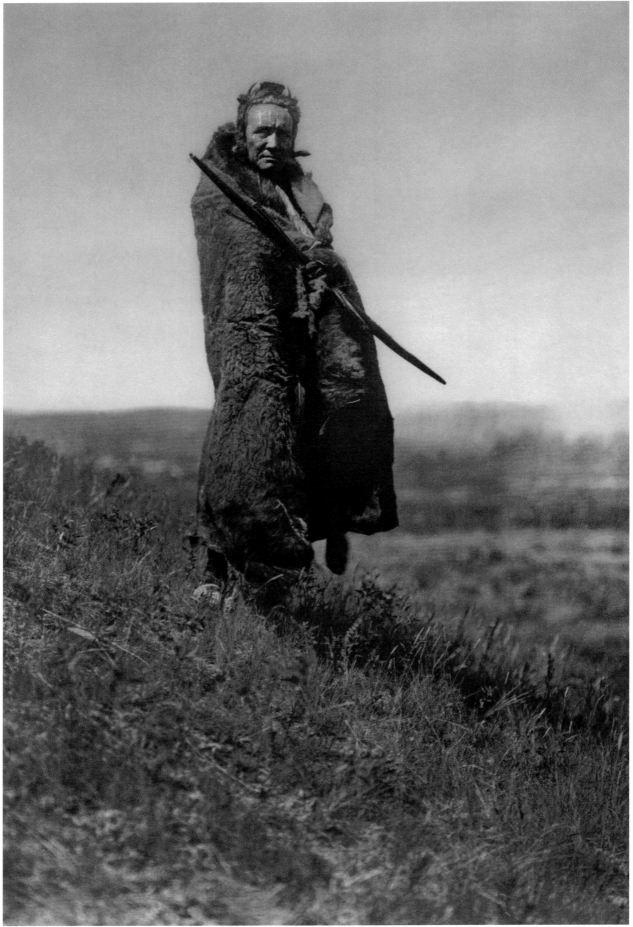

A Grizzly-bear Brave—Piegan, 1911

Plate 77

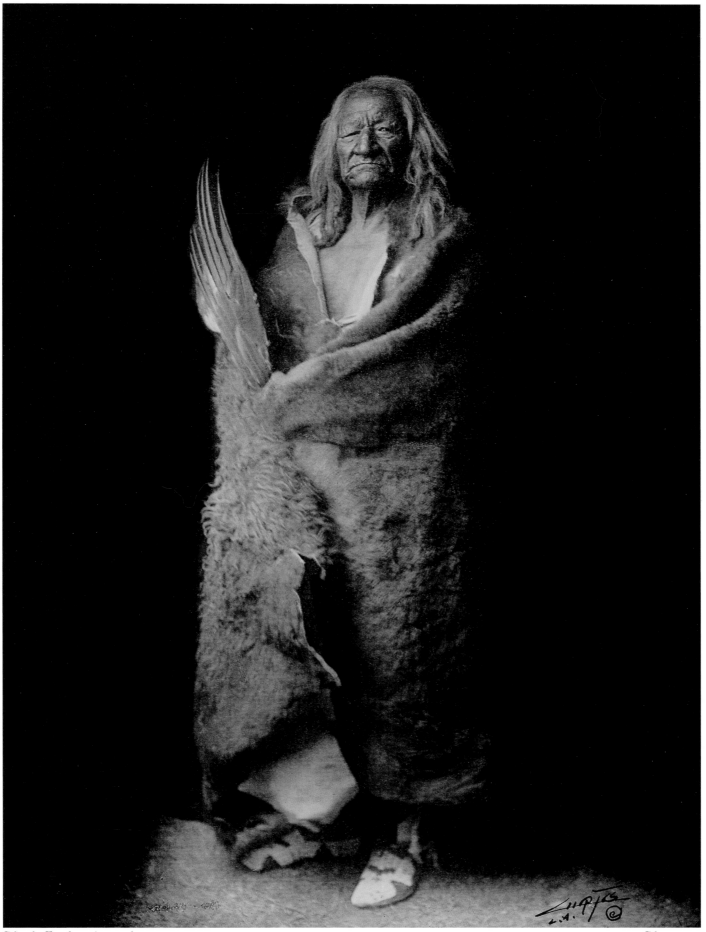

Black Eagle—Assiniboin, 1908

Plate 78

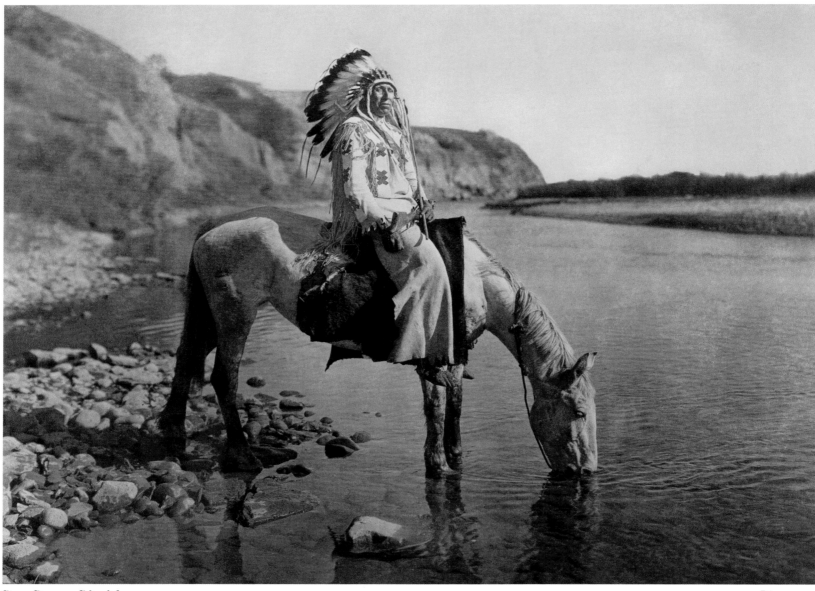

Bow River—Blackfoot, 1928 Plate 79

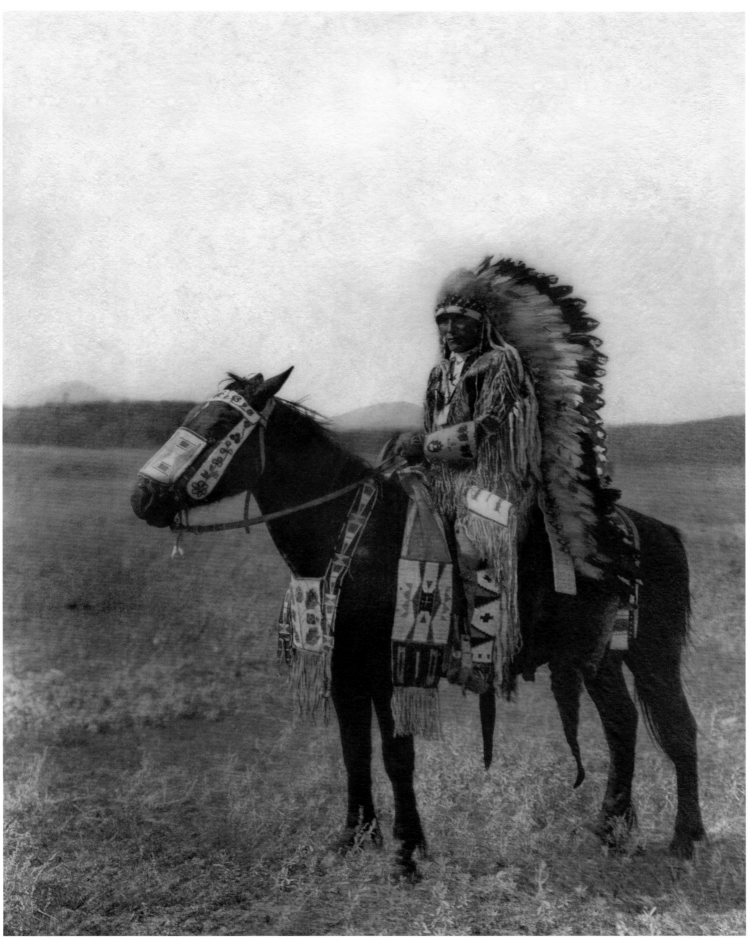

Chief Hector—Assiniboin, 1928 Plate 80

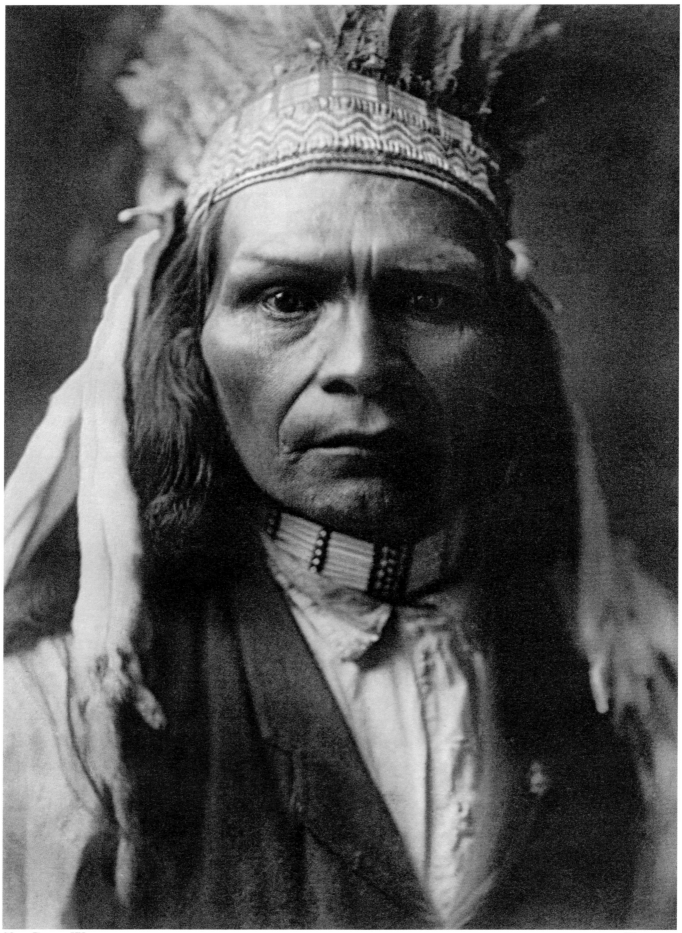

Nez Percé Warrior, 1911 Plate 81

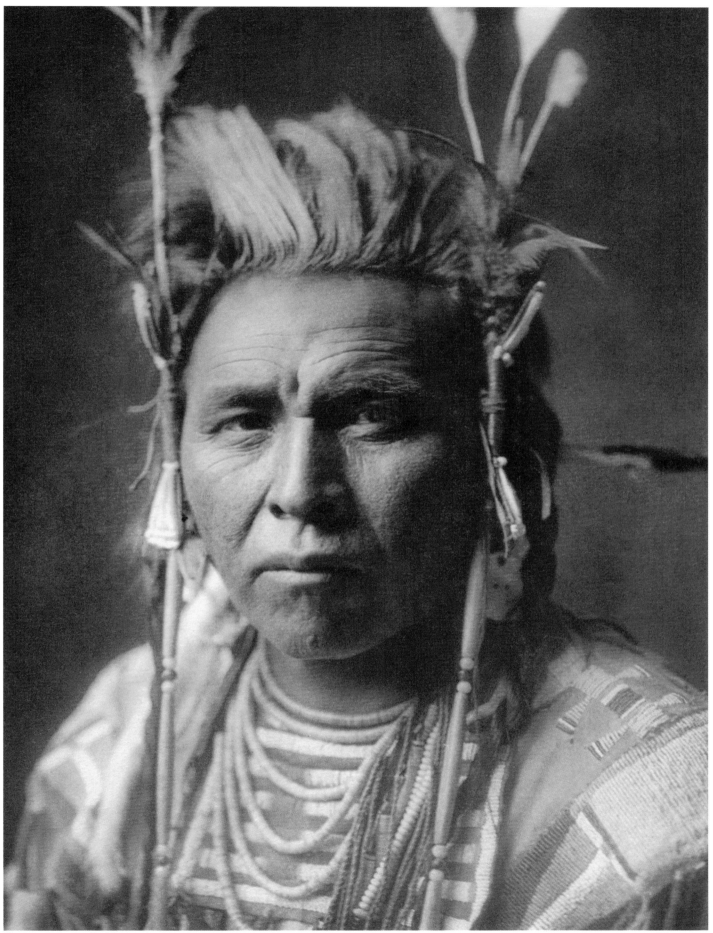

Spotted Jack Rabbit—Apsaroke, 1909 Plate 82

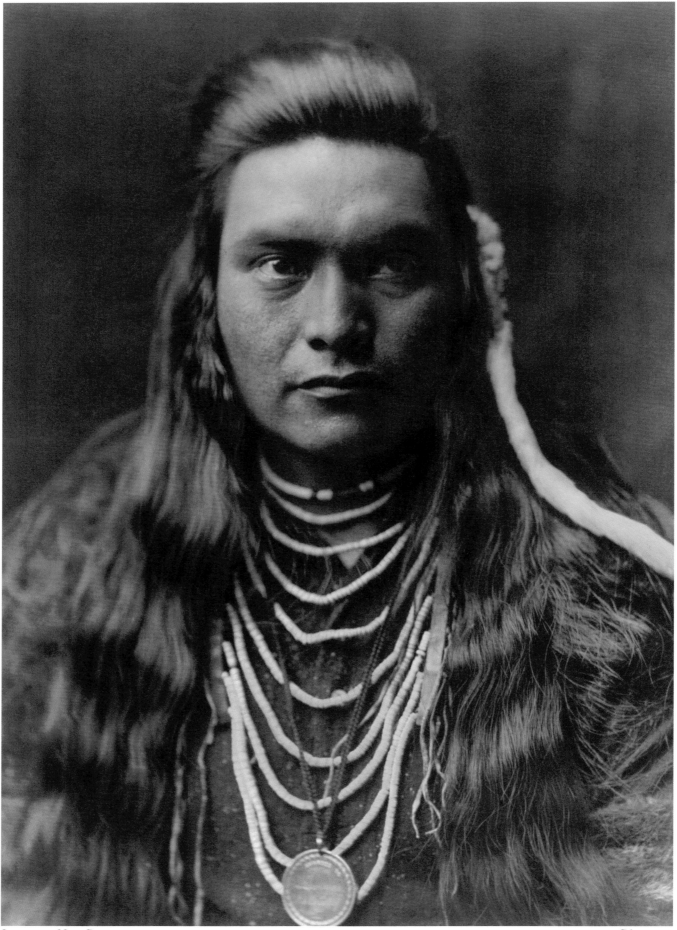

Lawyer—Nez Percé, 1911 Plate 83

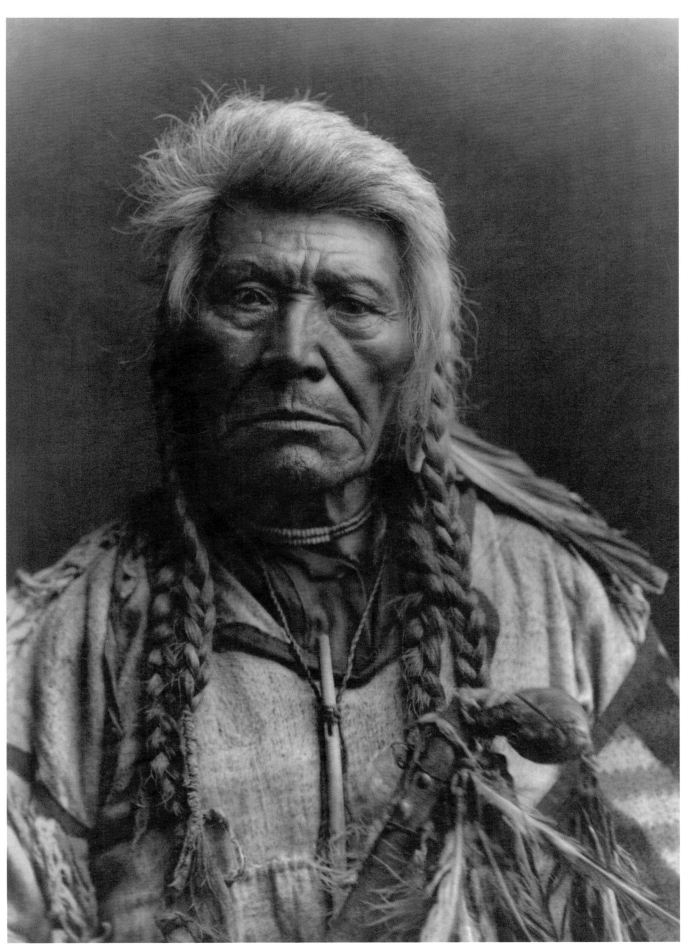

A Flathead Chief, 1911

Plate 84

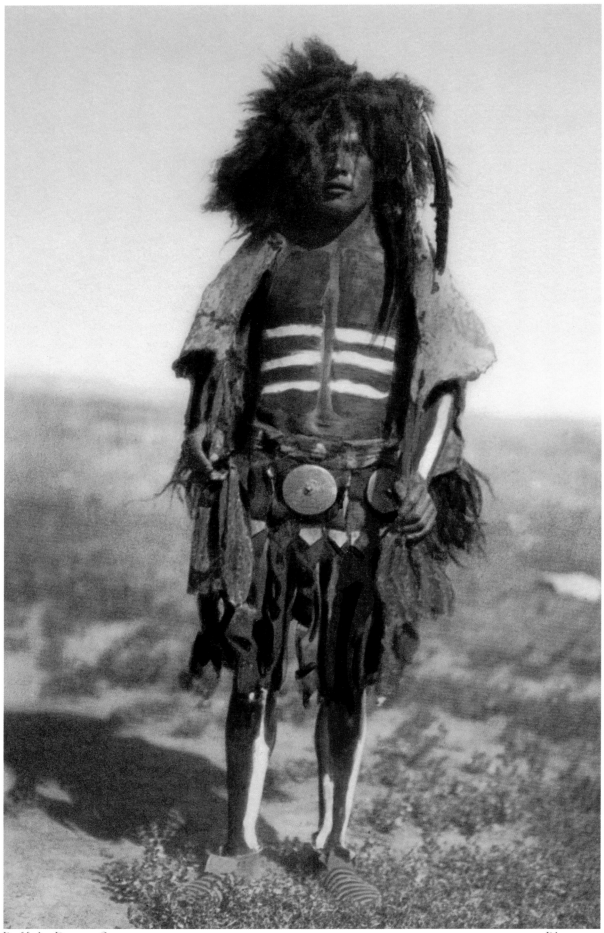

Plate 85

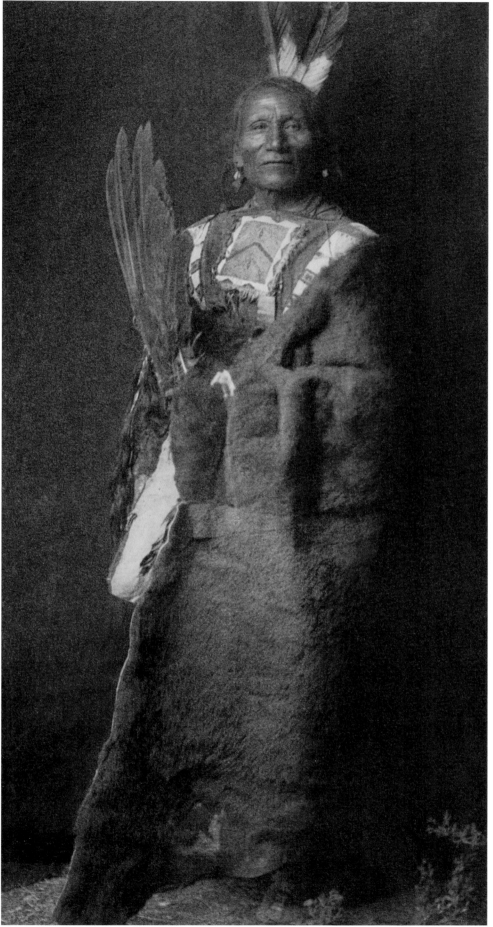

Gray Bear—Yanktonai, 1908 Plate 86

All birds, even those of the same species, are not alike, and it is the same with animals and with human beings. The reason Wakantanka does not make two birds, or animals, or human beings exactly alike is because each is placed here by Wakantanka to be an independent individuality and to rely upon itself.

—Shooter, Teton Sioux

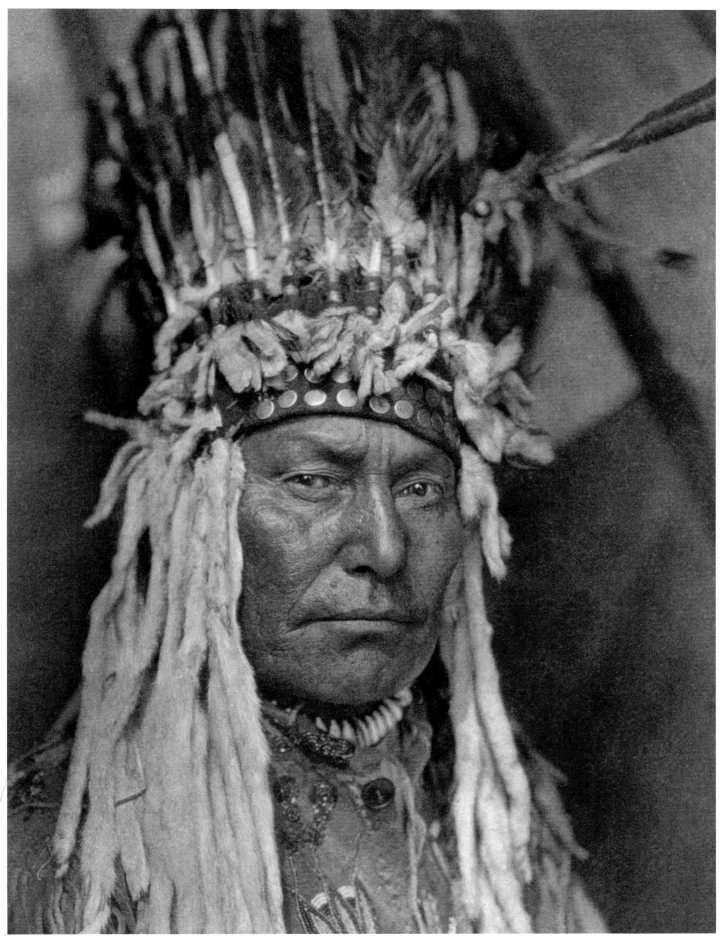

A Piegan War-bonnet, 1928

Plate 87

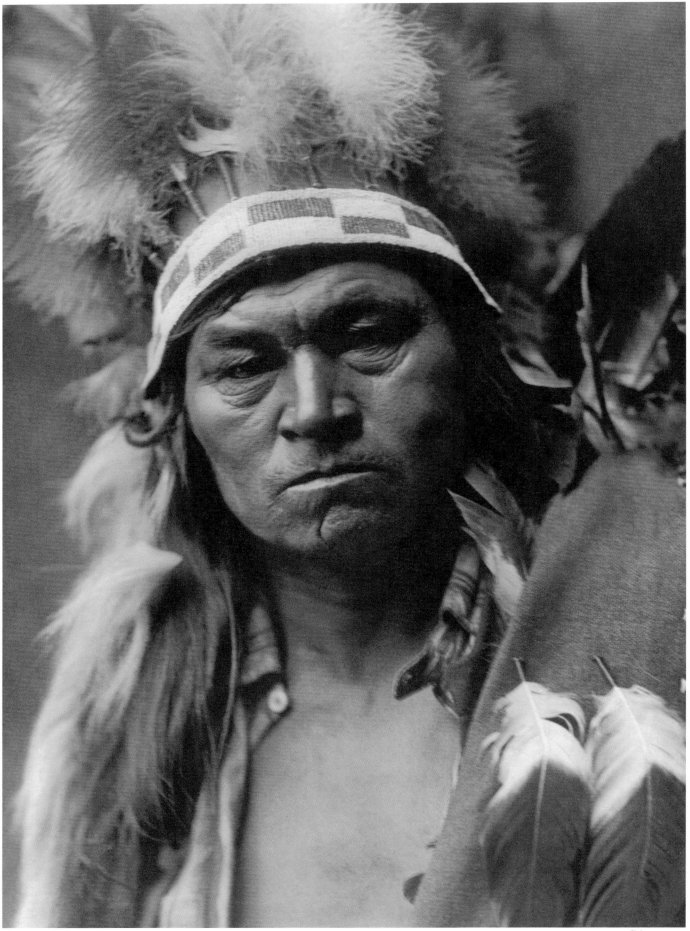

Cayuse Warrior, 1911

Plate 88

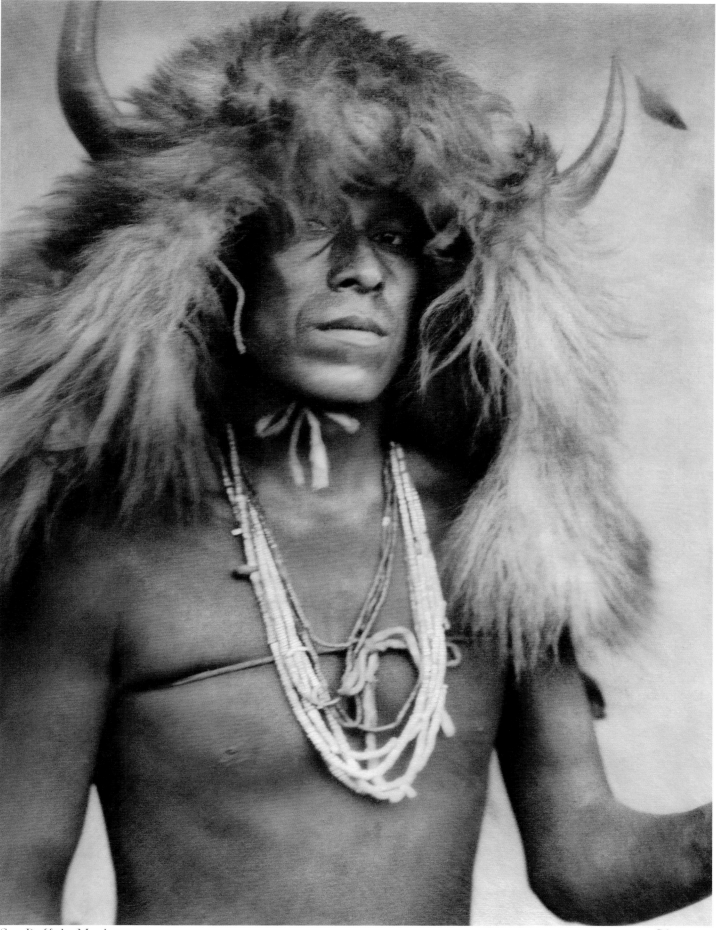

Sia Buffalo Mask, 1926 Plate 89

Out of the Indian approach to life there came a great freedom—an intense and absorbing love for nature; a respect for life; enriching faith in a Supreme Power; and principles of truth, honesty, generosity, equity, and brotherhood as a guide to mundane relations.

—Luther Standing Bear, Oglala Sioux Chief

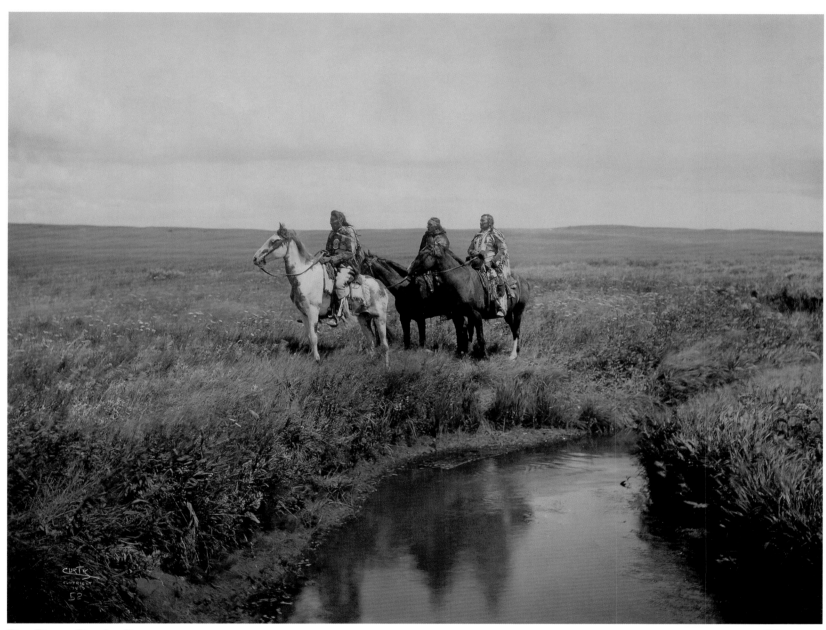

The Three Chiefs—Piegan, 1911

Plate 90

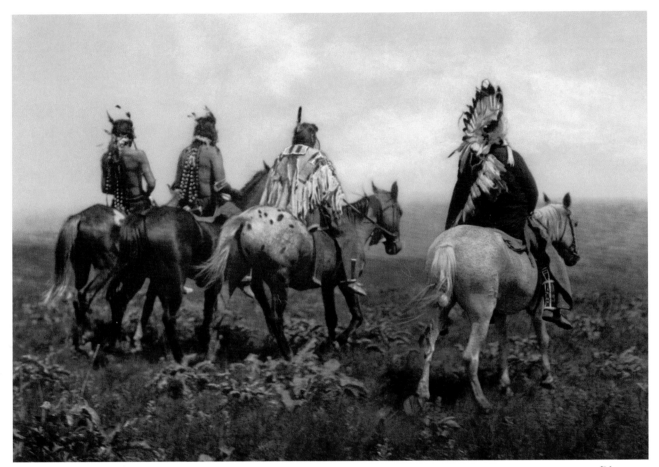

The Chief and His Staff—Apsaroke, 1909 Plate 91

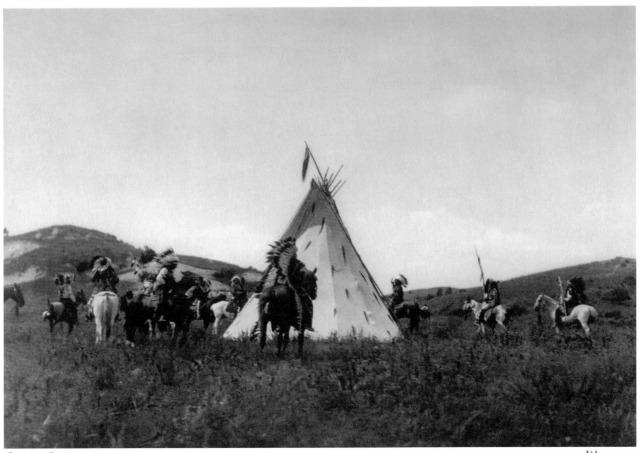

Sioux Camp, 1908 Plate 92

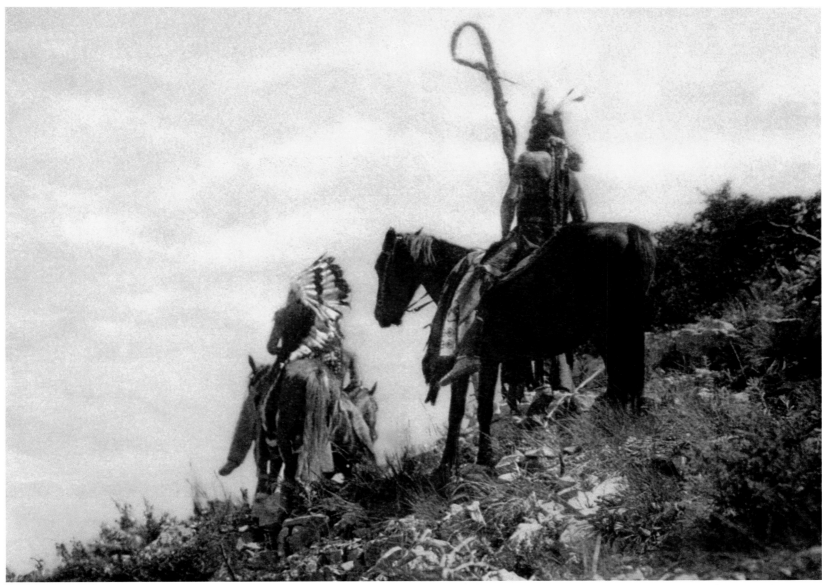

The Lookout—Apsaroke, 1909 Plate 93

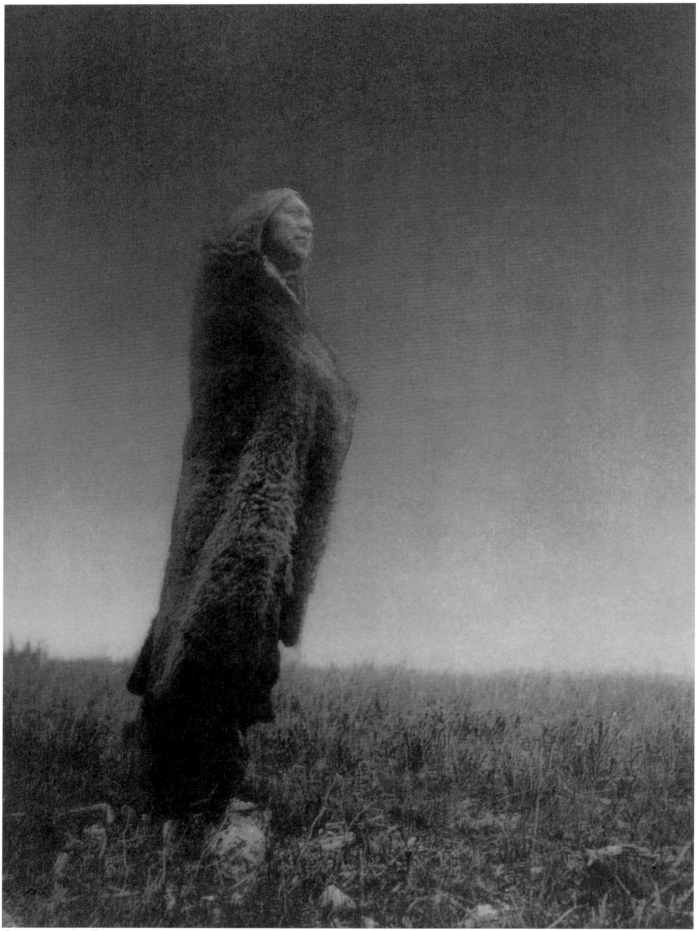

Crying to the Spirits, 1909

Plate 94

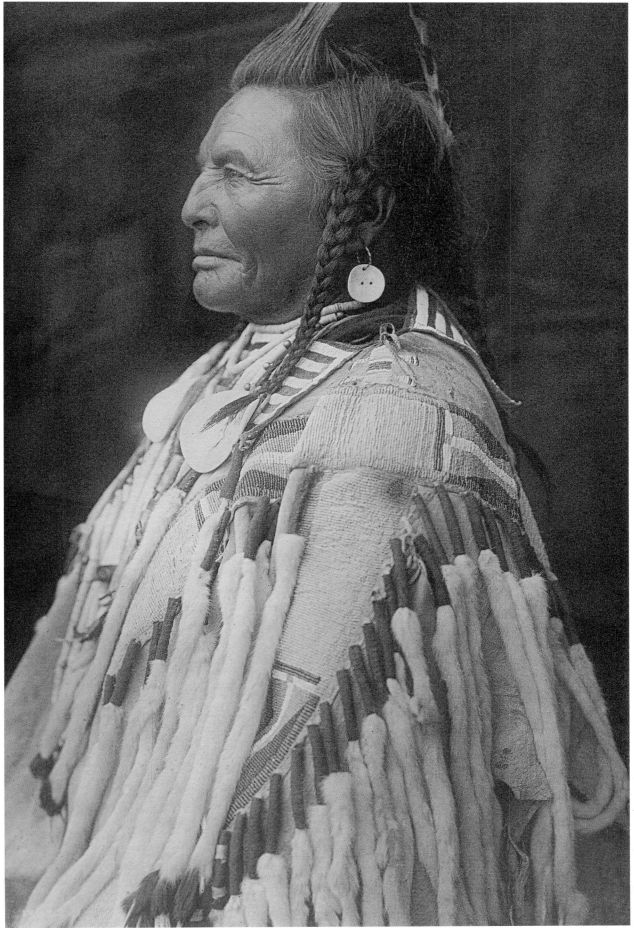

Shot in the Hand—Apsaroke, 1908

Plate 95

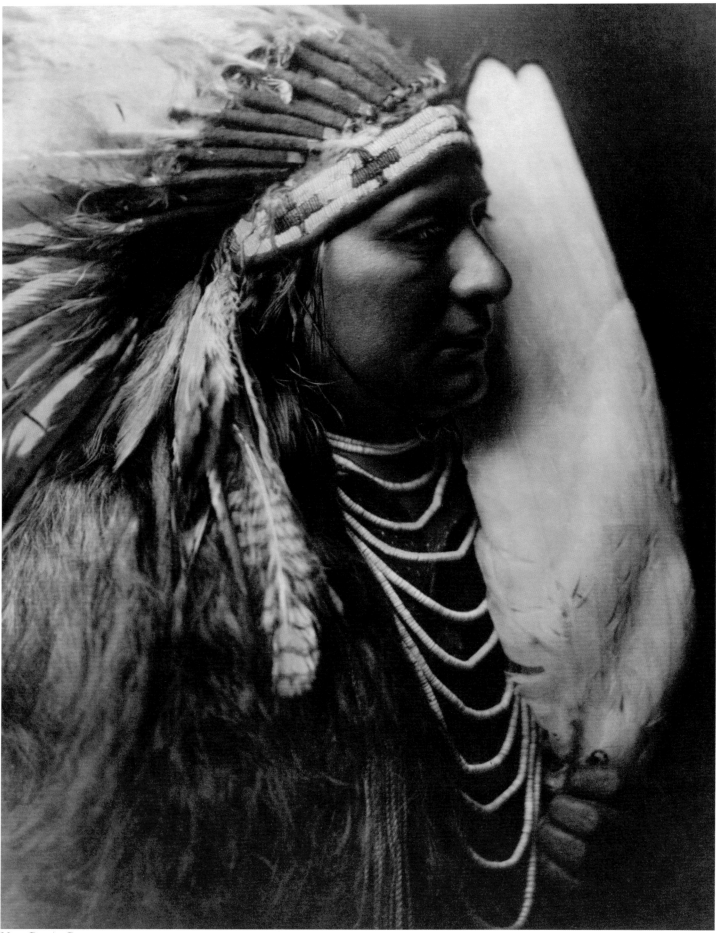

Nez Percé Brave, 1911

Plate 96

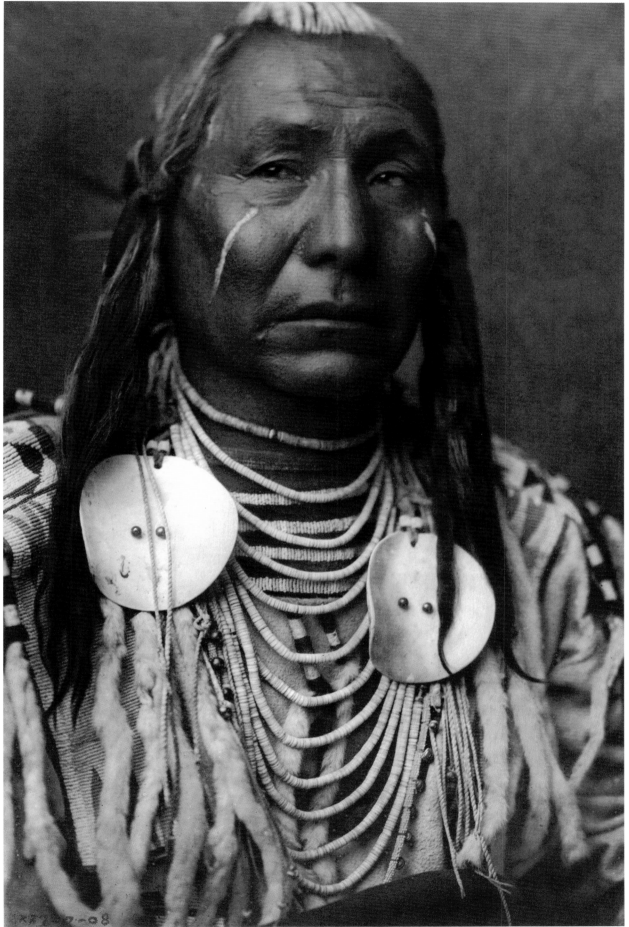

Red Wing—Apsaroke, 1909

Plate 97

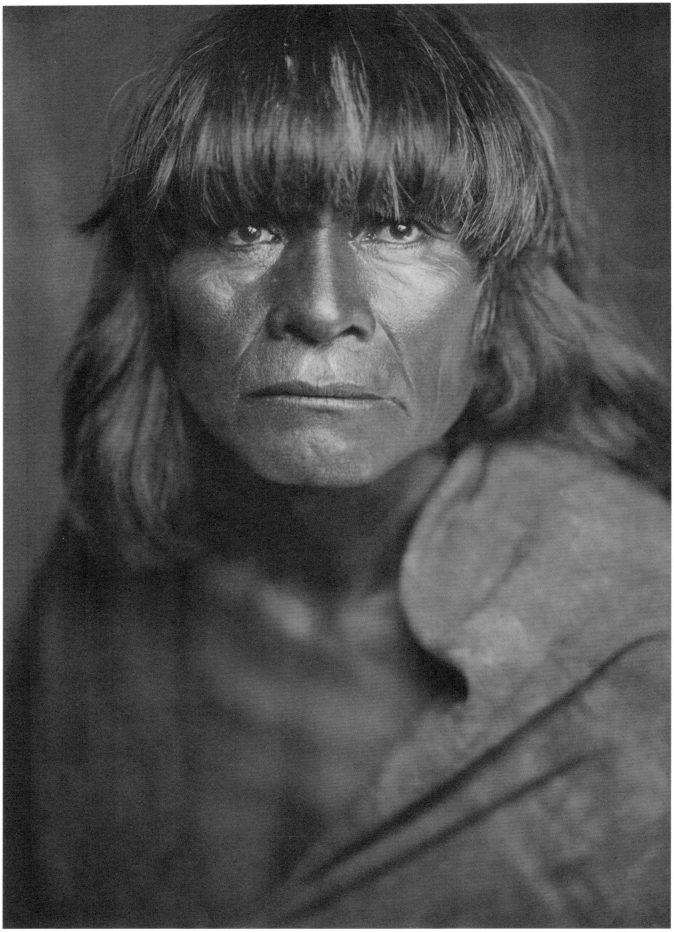

A Hopi Man, 1922 Plate 98

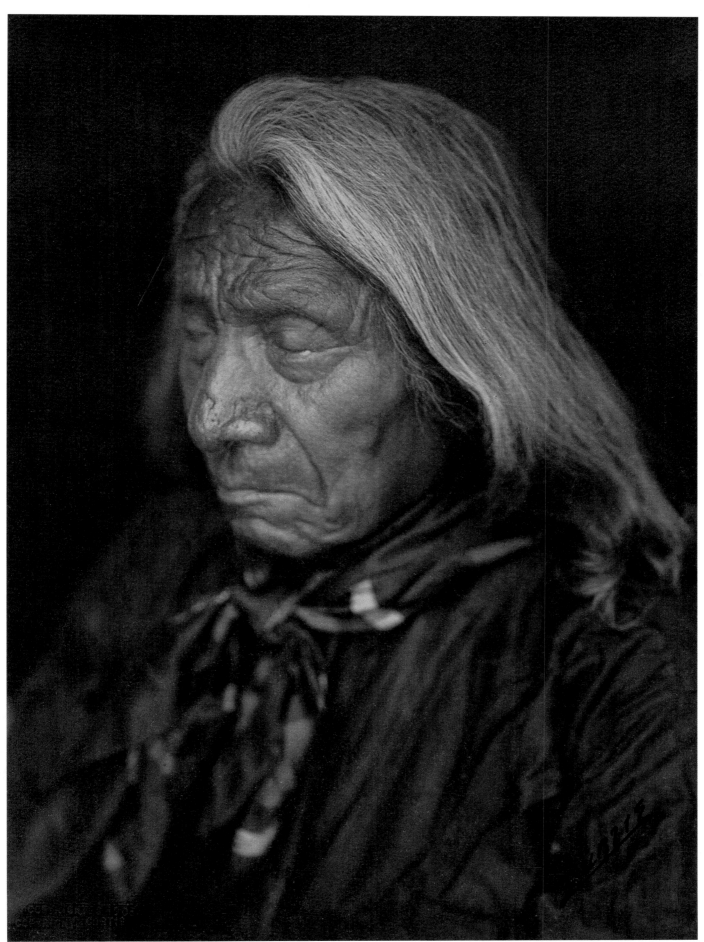

Red Cloud—Oglala, 1908

Plate 99

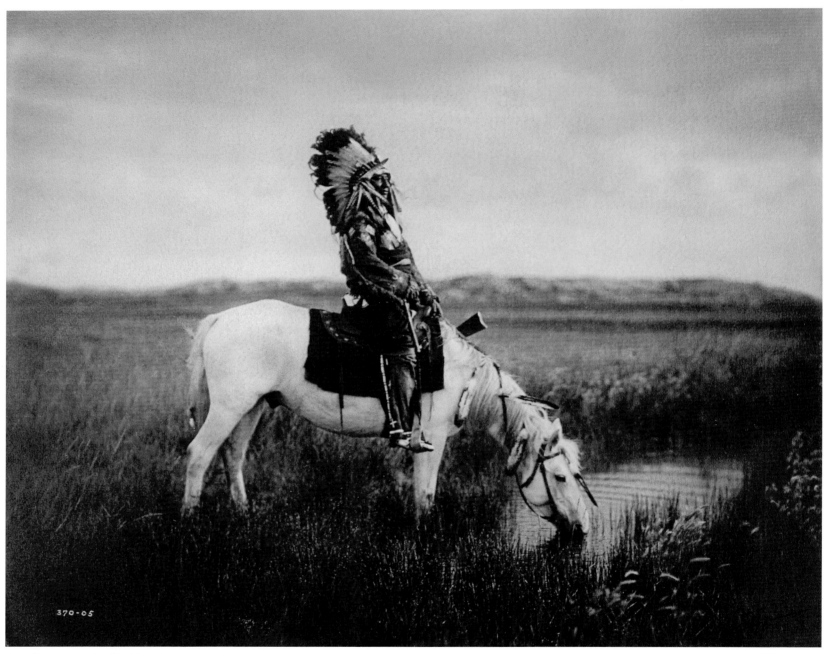

An Oasis in the Badlands, 1908 Plate 100

I was born upon the prairie, where the wind blew free, and there was nothing to break the light of the sun. I was born where there were no enclosures, and where everything drew a free breath...I know every stream and every wood between the Rio Grande and the Arkansas. I have hunted and lived over that country. I lived like my fathers before me, and like them, I lived happily.

—Ten Bears, Yamparethka Commanche Chief

Afterword

Anne Makepeace

Curtis first spoke to me from his photographs. In the 1980s I came upon his sepia-toned pictures of American Indians in friends' houses, on postcards, on book jackets and posters, and occasionally in a gallery or museum. I began reading everything I could about his life and work, and was immediately struck by the amazing drama of his story. Edward Curtis was a pioneer in every sense of the word, a homesteader on Puget Sound who taught himself photography and became for a time the most famous photographer in America. His life has the structure of classic tragedy; determined to capture the beautiful in Indian life, he sacrificed fame, family, and fortune to complete his giant opus.

As a filmmaker, I found Curtis's story deeply compelling. I decided to make a film about him, a documentary that would include American Indian people's responses to his work, as well as contemporary footage of ceremonies that Curtis had photographed a hundred years ago. In many ways my journey of making *Coming to Light* paralleled Curtis' 30-year odyssey. Like Curtis, I raced back and forth across the country, fundraising in New York and Washington, then camping out on Indian reservations in the West and struggling to win the support of people who were justifiably suspicious of Anglo outsiders, especially when cameras were involved.

It became clear to me that genuine respect and stoic patience were the keys to Curtis' success in working with Indian people. At a time when most Americans considered Native Americans an inferior race of stone-age savages, Curtis wrote, "There is a marvelous beauty in their free poetic thought full of imagery such as few white men ever knew; their souls are those of poets." He was sincerely interested in their cultures, and made personal connections with those he photographed. "I said we, not you. In other words I worked with them, not at them."

I had been especially moved by Curtis' portraits of Geronimo, Red Cloud, and Joseph, famous chiefs who had resisted the onslaughts of the United States Army for decades, but who were prisoners of war when Curtis met them. I wondered how Curtis had convinced these men to pose for him, what their photographic sessions had been like, and how he had been able to capture such complexity in their expressions: defiance, pride, heartbreak, resilience.

One of the first chiefs Curtis photographed was the Nez Percé leader, Chief Joseph, who came to his studio in 1904 on a speaking tour. Curtis was moved by the chief's grace and by his determination to bring his people home to the Wallowa Valley. When Joseph died a year later, Curtis wrote, "At last his long, endless fight for his return to the old home is at an end… Perhaps he was not quite what we in our minds had pictured him, but still I think he was one of the greatest men that had ever lived. I only wish that I could have had the opportunity to have spent more time with him and tried to learn more of his real nature." Perhaps it was this loss that influenced the way Curtis related to other great chiefs.

Curtis first met Geronimo in 1905. The old chief had given up fighting long before, but he did not often choose to cooperate with his captors. They met at the Carlisle Indian school where Geronimo had been taken to observe the progress of Apache children. The students wore uniforms, their hair shorn, their traditional clothes burned. Curtis must have felt empathy for these children who were thousands of miles from their homes, and light years away from their cultures. It may have been this feeling that connected Curtis and Geronimo at Carlisle. In one of the portraits,

Geronimo looks off to his right, his face lost in thought. Perhaps he is thinking of his violent past, or of the thorny path his descendants must now follow. Curtis allowed Geronimo this moment, not hurrying, letting him fall into a reverie that reveals his emotional landscape.

A few days later, Curtis photographed Geronimo again, riding in President Roosevelt's inaugural parade. Curtis described the cold, miserable day: "As I approached in a drizzle of rain, I saw a tall figure wrapped from head to foot in a bright red blanket who waited for me. It was my old friend Geronimo. He opened his right arm wide and pulled me under his protecting blanket and we proceeded together." With patience, empathy, and admiration, Curtis had won the friendship of the great Chief Geronimo.

Later that year Curtis photographed the ancient Sioux warrior Red Cloud at the Pine Ridge reservation. Red Cloud allowed Curtis to photograph him, but refused to speak. Curtis wrote, "Ninety-one years old, blind, almost deaf, he sits dreaming of the past. No wonder he is irritated by the idle information seeker! Who would be called back from the dreams of his youth? Sightless and infirm, he is living over the days when in youth he sat his horse as a king, the pride of the great Sioux nation."

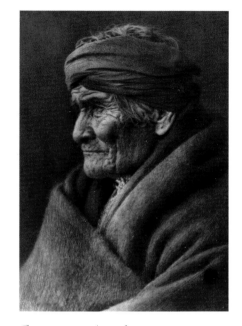

Geronimo—Apache, 1907

Discovering these photographs and writings by Curtis deeply influenced my own approach to Indian people. I learned to respect silence; not to hurry, but rather to make personal connections and to wait and see what would happen. It was this understanding that led me to the chief who had been most important to Curtis in all his thirty years of working with Indian people.

My cinematographer and I had just filmed a sand-painting on the Navajo reservation, and were headed back to Hopi for an interview with the grandson of Curtis' "Piki Maker." Sage and sunflowers glowed in the fading sunlight as we drove across the painted desert to First Mesa. But when we got there, the grandson had left. I was disappointed, but I also knew from my eight years of working at Hopi that whenever a plan fell through, something much better was around the corner.

The sun was setting in streaks of red, orange, and yellow as we drove on towards Second Mesa. Just before the village of Sipaulovi, we pulled into a dirt road and knocked on the door of a tiny cabin to ask permission to film the sunset. Out came a weathered, twinkling old man named Riley Sunrise. I showed him my book of Curtis' Hopi photographs as a courtesy and he became very excited. He said that, as a boy, he had worked for Curtis, carrying cameras and being the "Gunga Din of the Hopi land."

While my cinematographer shot the sunset, Riley and I looked through the pictures. He stopped dead at one called "A Hopi Man," a photograph I had been trying to identify for years. "That's my grandfather, Sikyaletstiwa. He was the Snake Chief." A lightbulb went off in my head. Sikyaletstiwa must have been the chief who initiated Curtis into the Snake Society. Curtis had met him in 1900 and said, "After witnessing the Snake Dance Ceremony in the plaza I was profoundly moved, and realized if I was to fully understand its significance, I must participate, if permission could be obtained. To this end I returned over a period of many years, twelve in fact, renewing my acquaintance with the Snake Priest as well as my sincere request to be made a priest in the ceremony. Finally in 1912 permission was granted and I was initiated into that order; to my knowledge the only white man who has done so." Inside the Snake Kiva, Sikyaletstiwa had adopted Curtis, saying "If you will call me father, I will call you my son," and had revealed the ritual's secrets.

In the portrait, entitled "A Hopi Man," Sikyaletstiwa gazes directly at the camera with an expression that speaks volumes. Just off-screen, outside Curtis' photographic tent, missionaries and government officials are doing everything they can to destroy Hopi culture. "Are you my friend?" he seems to ask. "Can I trust you? Will your pictures show the world that our way of life is good?" Hopis believed then (and many still do) that the well-being of the world depends on their cycle of rituals. Perhaps Sikyaletstiwa is wondering, Can your work save us all? Or will this fourth world we live in be destroyed? ❋

Plate List

Unless otherwise noted, all prints reproduced in this volume are from Curtis' magnum opus, *The North American Indian*, and were originally printed using the photogravure process. Descriptions in italics are drawn from the writings of Edward S. Curtis.

Title Page - Raven Blanket—Nez Percé, 1910

This lovely portrait shows a proud and powerful Nez Percé warrior in full regalia replete with beadwork and winter ermine tails.

Page 7 - The Vanishing Race—Navaho, 1904

The thought which this picture is meant to convey is that the Indians as a race, already shorn of their tribal strength and stripped of their primitive dress, are passing into the darkness of an unknown future. Feeling that the picture expresses so much of the thought that inspired the entire work, the author has chosen it as the first of the series.

Page 9 - Untitled
(Portrait of Curtis with Native Americans)

Hand-colored gelatin silver print. Photographer unknown. Size 10 7/8 x 7, photographed circa early 1900's.

Page 10 - Untitled—Nootka, 1915

Un-toned silver reference print. Unsigned, unpublished, image size 7 13/16 x 4 11/16. Photographed circa 1911.

Plate Section - Chief Joseph—Nez Percé, 1911

Chief Joseph (1840-1904) was one of the most revered Chiefs and is most often associated with the following quote: "I am tired of fighting. Our chiefs are killed...It is cold and we have no blankets. The little children are freezing to death. My people, some of them, have run away to the hills and have no blankets, no food; no one knows where they are, perhaps freezing to death. I want to have time to look for my children and see how many of them I can find. Maybe I shall find them among the dead. Hear me, my chiefs. I am tired; my heart is sick and sad. From where the sun now stands I will fight no more forever."

Plate 1 - Medicine Crow—Apsaroke War Chief, 1909

The three fox-tails hanging from the coup-stick show the subject (Medicine Crow) to be the possessor of three first coups. The necklace consists of beads, and the large ornaments at the shoulders are abalone shells.

Plate 2 - Bear's Belly—Arikara, 1909

Born in 1847 at Fort Clark in the present North Dakota. He became a member of the Bears in the medicine fraternity and relates the story of an occurrence connected with that event, which is reprinted on the page facing plate 2.

Plate 3 - Medicine Crow—Apsaroke, 1909

The hawk fastened on the head is illustrative of the manner of wearing the symbol of one's tutelary spirit. Born in 1848, he led ten successful war-parties during his life. His medicine of hawk was purchased from another man. Platinum Print

Plate 4 - Mosquito Hawk—Assiniboin, 1908

Born on the Missouri below Williston, North Dakota, he followed his first war party at the age of fourteen, but gained no honors. He fought against the Piegan, killed two, took a scalp, and counted his first coup.

Plate 5 - Good Lance—Oglala, 1908

Born in 1846, he participated in ninety raids, mostly against the Pawnee. He purchased medicine of pulverized roots tied in deerskin from a Cheyenne medicine man, as a charm against arrows and bullets.

Plate 6 - Crow's Heart—Mandan, 1909

Mandan war-honors were marked by a single eagle feather worn in the hair, with red lines noting the grade of the honors. The first three coups were marked by three black spirals painted on the right legging.

Plate 7 - Jack Red Cloud, 1908

The subject of this portrait is the son of the great Oglala chief Red Cloud.

Plate 8 - Struck by Crow—Oglala, 1908

Born 1847. He fought four times against troops, three of these occasions being the Fetterman massacre, the engagement with Crook's command at the Rosebud, and the battle of the Little Bighorn.

Plate 9 - The Old Cheyenne, 1930

The Cheyenne wore clothing common to the tribes of the plains: hip leggings of deer or buffalo skin, breechcloth, and moccasins of deer, elk, or buffalo skin with rawhide soles.

Plate 10 - The Piegan, 1911

This scene on Two Medicine River near the eastern foothills of the Rocky mountains is typical of the western portion of the Piegan country, where the undulating upland prairies become rougher and more broken, and finally give place abruptly to mountains.

Plate 11 - Cheyenne Warriors, 1911

In addition to the their dances and raids, the warrior societies served as the camp police, preserved order on the general buffalo hunt, and enforced the orders of the chiefs. Their wishes were consulted before any matter of public interest was settled. They were in fact the real ruling power, the only body that could compel obedience.

Plate 12 - Old Person—Piegan, 1911

The young men eagerly seize every occasion of public festivity to don the habiliments of their warrior fathers.

Plate 13 - A Chief of the Desert—Navaho, 1907

Picturing not only the individual but a characteristic member of the tribe — disdainful, energetic, self-reliant. Platinum Print.

Plate 14 - The Scout—Apache, 1907

The primitive Apache in his mountain home. The backlighting/silhouetting is a classic Pictorialist device often used by Curtis to emphasize emotional and spiritual qualities over the purely documentary. Platinum Print.

Plate 15 - The Medicine Man—Sioux, 1908

Invocation and supplication enter so much into the life of the Indian that this picture of the old warrior invoking the Mysteries is most characteristic. The subject of the illustration is Slow Bull (also shown in the close-up portrait Plate 84.) Silver Border Print.

Plate 16 - High Hawk—Brulé-Sioux, 1908

The subject is shown in all the finery of a warrior dressed for a gala occasion — scalp-shirt, leggings, moccasins, and pipe-bag, all embroidered with porcupine-quills; eagle-feather war-bonnet and stone headed war-club from the handle of which dangles a scalp. High Hawk is prominent among the Brulés mainly because he is now their leading historical authority, being much in demand to determine the dates of events important to his fellow tribesmen.

Plate 17 - Bread—Apsaroke, 1909

Born in 1863. His first war experience was under Young Wolf Calf, when a party captured a hundred horses from the Piegan. On another occasion, under Wet, he captured a horse from the Yanktonai.

Plate 18 - Long Fox—Assiniboin, 1908

Born in 1827 near Fort Berthold, North Dakota. He joined a war-party against the Mandan, capturing three horses, and a party against the Sioux, capturing seven horses.

Plate 19 - Vash Gon—Jicarilla 1907

The men wear their hair in braids hanging over the shoulders and wound with strips of deer-skin.

Plate 20 - The Chief—Klamath, 1924

The subject of this plate, in deerskin suit and feathered war-bonnet of the Plains culture, is shown against a background of Crater Lake and its precipitous rim towering a thousand feet above the water.

Plate 21 - On Spokane River, 1911

Spokane river, from a short distance above its head in Coeur d'Alene Lake to its confluence with the Columbia, flows through the midst of what was the territory of the Spokan Indians. The character of the country through which the stream passes for some miles above its mouth is well shown in the picture. Northward from the stream lie the mountains among which the three Spokan tribes hunted deer and gathered berries, and southward stretch the undulating plains where they obtained their supply of roots.

Plate 22 - The Spirit of the Past, 1909

A particularly striking group of old-time warriors, conveying so much of the feeling of the early days of the chase and the war-path that the picture seems to reflect in an unusual degree the "spirit of the past."

Plate 23 - The Oath, Apsaroke, 1909

In this photograph the Apsaroke warrior, Picket Pin, takes an oath of truth and honor while two other warriors act as witnesses. The Oath requires the man to thrust an arrow through a piece of meat, place it upon a red-painted buffalo skull, raise it toward the sun and, if his words are true, touch the meat to his mouth. The ceremony was intended for use with difficult or controversial communications to help insure both the veracity and good intentions of the speaker.

Plate 24 - Iron Breast—Piegan, 1911

The picture illustrates the costume of a member of the Bulls a society formed about 1820 by a man who had a dream in the mountains, saw a certain kind of dance, and on his return made the necessary insignia, sold it to a number of old men, and instructed them in the songs and dance. All wore buffalo robes with the hairy side exposed.

Plate 25 - Untitled (Nez Percé Brave, 1899)

This early Curtis photograph of an unidentified Nez Percé was made in 1899. It is hand-signed and numbered negative #19. Platinum Print.

Plate 26 - Horse Capture—Atsina, 1909

Born near Milk River, Montana, in 1858. His tribe, the Atsina, commonly designated Gros Ventres of the Prairie, are of the Algonquian stock and a branch of the Arapaho. Their name for themselves is Aáninen, Atsina being their Blackfoot name.

Plate 27 - Two Leggings—Apsaroke, 1909

Born about 1848. Two Leggings became a war-leader. Led two parties against the Hunkpapa Sioux, each time taking scalps. Captured fifty horses from the Yanktonai at Fort Peck, and with Deaf Bull led a party that brought back eighty horses from the Teton Sioux.

Plate 28 - Spotted Bull—Mandan, 1909

Mandan tradition and legend tell of a gradual migration up the Missouri "from the place where the river flows in to the great water," and frequent are the allusions in their stories to the land of the south where the green of the trees never faded and the birds were always singing. Curtis noted that Spotted Bull's physiognomy was not typical of the Mandan and may have been the result of intermarrying with the Dakota.

Plate 29 - Eskadi—Apache, 1907

A headman of one of the bands, and a particularly fine Apache type.

Plate 30 - Little Hawk—Brulé, 1908

This portrait exhibits the typical Brulé physiognomy. The Brulé were plains Indians.

Plate 31 - Weasel Tail—Piegan, 1911

The accoutrement of this brave (Apohsuyis) comprise the well-known war-bonnet of eagle-feathers and weasel-skins, deerskin shirt, bone necklace, grizzly-bear claw necklace, and tomahawk-pipe of the Hudson's Bay Company origin.

Plate 32 - For a Winter Campaign—Apsaroke, 1909

It was not uncommon for Apsaroke war-parties, mounted or afoot, to move against the enemy in the depth of winter. The warrior at the left wears the hooded overcoat of heavy blanket material that was generally adopted by the Apsaroke after the arrival of traders among them. The picture was made in a narrow valley among the Pryor Mountains, Montana.

Plate 33 - The Blackfoot Country, 1928

Since the beginning of the historical period the Blackfeet have ranged the prairies along Bow river, while their allies, the Bloods and Piegan, were respectively on Belly and Old Man rivers. In the earliest times of which their traditionists have knowledge the three tribes were respectively on Saskatchewan, Red Deer, and Bow rivers.

Plate 34 - Wolf Lies Down—Apsaroke, 1909

Born about 1843. He paid 500 elk teeth for his medicine of wolf.

Plate 35 - Red Whip—Atsina, 1909

Born in 1858 near Fort McGinnis, Montana. At the age of seventeen he went out on his first war expedition, going against the Sioux. The enemy was camped at Lodgepole Creek, and the Atsina attacked them at dawn, capturing several horses. Red Whip was in the lead of the charge and took a few of the animals single-handedly.

Plate 36 - Waihusiwa, A Zuni Kyáqimàssi, 1926

Kyáqi-mássi ("house chief") is the title of the Shiwánni of the north, the most important of all Zuni priests. Waihusiwa in his youth spent the summer and fall of 1886 in the East with Frank Hamilton Cushing, and was the narrator of much of the lore published in Cushing's Zuni Folk Tales. A highly spiritual man, he is one of the most steadfast of the Zuni priests in upholding the traditions of the native religion.

Plate 37 - Tearing Lodge—Piegan, 1911

Pinokimin_ksh is one of the few Piegan of advanced years and retentive memory. He was born about 1835 on Judith River in what is now northern Montana, and was found to be a valuable informant on many topics. The buffalo-skin cap is part of his war costume, and was made and worn at the command of a spirit in a vision.

Plate 38 - Bull Chief—Apsaroke, 1909

Born in 1825. Believing he could win success without fasting, he joined many war-parties, but always returned without honor. After several unsuccessful attempts at fasting, he fasted at the head of Redlodge Creek for four days and four nights, much of the time in blinding snow. He saw his own lodge and a splendid bay horse standing in front of it. The vision was soon followed by the capture of a tethered bay, his first honor. He frequently counted coup from then on and was married fifteen times.

Plate 39 - Ready for the Charge—Apsaroke, 1909

The picture shows well the old-time warrior with bow and arrow in position, two extra shafts in his bow-hand, and a fourth between his teeth ready for instant use.

Plate 40 - Apsaroke War Group, 1909

The warrior at the right holds the curved staff of one of the tribal military organizations, which, at the time of a fight, was planted in the ground as a standard behind which the bearer was pledged not to retreat.

Plate 41 - In the Land of the Sioux, 1908

This picture illustrates the general character of the Sioux country. The broad, rolling prairie is broken by low hills, while here and there lie pools of stagnant water in old buffalo-wallows. The subjects of the picture are Red Hawk, Crazy Thunder, and Holy Skin, three Oglala who accompanied Curtis on a trip into the Bad Lands.

Plate 42 - Atsina Warriors, 1909

The Atsina have been mentioned comparatively little in history, partly, no doubt, because of their isolation and of their indisposition to show the same hostility toward advancing civilization as their neighbors...Yet the record of their tribal wars shows no indication of deficiency in courage or vigor.

Plate 43 - A Piegan Dandy, 1911

The Piegan, with the kindred Blackfeet and Bloods, were a vigorous people, roaming over a vast territory, half in the United States and half in British America. Being noted hunters with great quantities of furs and hides for barter, their territory was an important one to traders.

Plate 44 - Little Sioux—Arikara, 1909

The Arikara are an offshoot of the Pawnee tribe. They covered a vast range of territory, moving from the southern drainage of the Mississippi to Knife River in North Dakota.

Plate 45 - Four Horns—Arikara, 1909

Born in 1847 near Fort Berthold. Enlisted as a scout at Fort Buford; he served also at Fort Phil. Kearny, where in a skirmish with Sioux he had a horse shot under him. He fasted several times.

Plate 46 - The Old Time Warrior—Nez Percé, 1911

When a large (war) party was being organized, the names of the leaders were publicly announced, and in the evening was held a dance called Páhamn for the purpose of recruiting. The scalp-dance, or victory-dance, was like the same institution among the plains tribes.

Plate 47 - The Old Warrior—Arapaho, 1930

The Arapaho, of Algonquian stock like the Cheyenne, are divided into a Northern and Southern tribe, the former living on the Wind River reservation in Wyoming and the latter on the reservation assigned to them and the Cheyenne in the present Oklahoma in 1867.

Plate 48 - Untitled (Northern Plains Male)

This unidentified portrait of a Northern Plains male is reproduced from the original platinum print. While the original is signed, it is undated. The subject may well be Apsaroke. No other print is known to exist of this image. Platinum Print.

Plate 49 - Untitled (Male with Breastplate)

This unidentified Northern Plains Male warrior was photographed by Edward Curtis in 1905. The original is made in the rare platinum printing process. No negative of this image is known to have survived and this print is believed to be unique. Platinum Print.

Plate 50 - Two Whistles—Apsaroke, 1909

Born 1856. He never achieved a recognized coup, but at the age of eighteen he led a party consisting, besides himself, of two others, which captured a hundred horses from the Sioux. At the Crow agency in 1887 in the outbreak caused by the medicine-man Wraps Up His Tail, Two Whistles was shot in the arm and breast, necessitating the amputation of his arm above the elbow. His medicine of hawk was purchased with a horse from a Sioux.

Plate 51 - Chief Garfield—Jicarilla, 1907

Some years ago the Jicarillas were all officially given Spanish or English names. Many of them expressed a preference. This old man, who was head-chief of the tribe at the time, selected the designation Garfield.

Plate 52 - Kalispel Type, 1911

The Kalispel live in northeastern Washington, in the valley of Clark's Fort of the Columbia River, from about the place where the Idaho boundary crosses the stream down to Box Canon. The entire tribe consists of not more than a hundred persons who live in wooden houses and canvas covered tipis.

Plate 53 - Typical Nez Percé, 1899

This portrait presents a splendid type of the Nez Percé man. The Nez Percé are among the best known Indian Groups, and made a marked impression on explorers, traders, missionaries, and army officers. From the day they were first seen by Lewis and Clark in 1805 to the close of the Nez Percé War in 1877, those who were brought into contact with them found them to be exceptional people. Colodion Goldtoned Printing Out Paper Print.

Plate 54 - Unpublished, Negative #77, 1900

This unpublished portrait of a Northern Plains Male is a Colodian gold-toned printing out paper print. There are only two known copies of this print (both in the personal collection of Christopher Cardozo.) No negative is known to exist. This portrait was made during Curtis' seminal field trip to Montana with George Bird Grinnell in the summer of 1900.

Plate 55 - Brulé War Party, 1908

This rhythmic picture shows a party of Brulé Sioux reenacting a raid against the enemy.

Plate 56 - The Scout's Report—Atsina, 1909

The chief of the scouts, returning to the main party, tells in the vigorous and picturesque language so natural to the Indians what he has seen and experienced. While he speaks, the war-leader stands slightly in advance of his men, and carefully listening to the words of the scout, quickly forms his plan of action.

Plate 57 - The Parley—Sioux, 1908

The war-bonnet...could be worn only by men who had earned honors in war. When the young warrior had stuck the necessary coups, he procured the needed eagle-feathers, took them with suitable presents to some one skilled in fashioning war-bonnets, and asked him to make a head-dress, that he might wear it as evidence of his bravery.

Plate 58 - A Zuni Governor, 1926

This portrait may well be taken as representative of the typical Pueblo physiognomy. The intense presence and tight composition make this a classic Curtis portrait. Platinum Print.

Plate 59 - Slow Bull—Oglala, 1908

Born 1844. First war party at fourteen, under Red Cloud, against the Apsaroke. Engaged in fifty-five battles with Apsaroke, Shoshoni, Ute, Pawnee, Blackfeet, and Kutenai. Struck seven first coups. At seventeen he captured one hundred and seventy horses from Apsaroke...He had been a subchief of the Oglala since 1878.

Plate 60 - Untitled (Piegan)

This photograph of an unidentified Piegan warrior was made during Curtis' seminal field trip of 1900. Only two prints are known to exist from this negative. Colodion Goldtoned Printing Out Paper Print.

Plate 61 - Eagle Elk—Oglala, 1908

Born in 1853. At fourteen he went against the Apsaroke with a party which killed four near the Bighorn Mountains... Eagle Elk fought under Crazy Horse against General Miles at Tongue River, and under the same leader in the Custer fight. He fasted in the Black Hills four days and four nights, but had no vision, and never acquired any fighting medicine.

Plate 62 - Bear Bull—Blackfoot, 1928

The plate illustrates an ancient Blackfoot method of arranging the hair.

Plate 63 - Two Strike—Brulé-Sioux, 1908

Born in 1821, he gradually became head chief of the Brulés. He wore a bear's ear to "frighten the enemy."

Plate 64 - Luqaíòt—Kittitas, 1911

The original of this portrait is a son of Owhi (Óhai), who as chief of the Salishan band inhabiting Kittitas valley, Washington, at first appeared to favor the Stevens treaty of 1855, but a few months later was drawn into the Indian uprising by the act of another son, Qáhlchŭn, in killing some prospectors. At the termination of hostilities Luqaíòt made his permanent home among the Spokan, taking for his wife the daughter of a Spokan chief and widow of his executed brother Qáhlchŭn.

Plate 65 - Does Everything—Apsaroke, 1909

Born 1861. When only eighteen or twenty years of age he captured a gun, struck second dákshĕ, and killed two Piegan in one fight, thus receiving his name. Later he took two horses from the enemy's camp.

Plate 66 - Little Wolf- Cheyenne, 1911

One year after being captured at the Battle of the Little Muddy in 1877, Little Wolf escaped the inhospitable reservation he and his tribe were forced onto. He fought bravely, but was ultimately recaptured and forced to return to the reservation. Platinum Print.

Plate 67 - The Morning Attack, 1908

The favorite moment for attack was just at dawn, when the enemy was presumably unprepared to offer quick resistance.

Plate 68 - Arikara Chief, 1909

The tribal chief, Sitting Bear, is portrayed in full costume of scalp-shirt, leggings, and moccasins, all of deerskin; eagle-feather war-bonnet; and coup-stick.

Plate 69 - Flathead Warrior, 1911

The subject of this picture...is Black-tail Hawk, commonly called Pierre Lamoose, a descendant of the Iroquois Ignace La Mousse. His mother was a Flathead, his father half Kalispel and half Iroquois.

Plate 70 - The Whaler—Makah, 1916

Note the great size of the harpoon-shaft. Indian whalers implanted the harpoon-point by thrusting, not by hurling, the weapon.

Plate 71 - Masselow, Kalispel Chief, 1911

...Their chief, Masselow (a corruption of the French name Marcellon), son of his predecessor, Victor, controls them more by aid of tribal custom and the strong right arm of the peace officer, who at his command administers punishment with the lash...

Plate 72 - Nakoatok Chief and Copper, 1915

Hákalahl ("all over"), the head chief, is holding the copper Wánistakíla ("takes everything out of the house"). The name of the copper refers to the great expense of purchasing it. The copper is valued at five thousand blankets.

Plate 73 - Cowichan Warrior, 1913

The Cowichan were more war-like than the average Salish tribe. With only the Comox intervening between them and Kwakiutl tribes, they not only were influenced by the northern culture but perforce they imbibed something of the ferocity of those savage head-hunters.

Plate 74 - Klamath Warrior's Headdress, 1924

The material used in this peaked hat is tule stems, and the weaving is done by the twined process.

Plate 75 - Siwat—Awaitlala, 1915

Awaitlala means "those on the Inlet." This Northwest Coast image is from Coastal British Columbia.

Plate 76 - The Whaler, 1916

A feat so remarkable as the killing of a whale with the means possessed by primitive men is inexplicable to the Indian except on the ground that the hunter has the active assistance of a supernatural being. Prayers and numerous songs form a part of every whaler's ritual. The secrets of the profession are handed down from father to son.

Plate 77 - A Grizzly-bear Brave—Piegan, 1911

At least two of the Piegan warrior societies (the Braves and the All Brave Dogs) included in their membership two men known as Grizzly-bear Braves. It was their duty, at the time of the society dances, to provide their comrades with meat, which they appropriated wherever they could find it. Their expression and demeanor did justice to their name, and in their official capacity they were genuinely feared by the people.

Plate 78 - Black Eagle—Assiniboin, 1908

Born in 1834 on the Missouri below Williston, North Dakota. He was only thirteen years of age when he first went to war, and on this and the next two occasions he gained no honors. On his fourth war excursion he was more successful, capturing six horses of the Yanktonai alone. Silver Border Print.

Plate 79 - Bow River—Blackfoot, 1928

A Classic genre scene of Curtis' showing the proud warrior on horseback, overlooking a vast and inspiring landscape.

Plate 80 - Chief Hector—Assiniboin, 1928

The Assiniboin are an offshoot of the Yanktonai Sioux, from whom they separated prior to 1640. The southern branch has long been confined on a reservation in Montana, the northern is resident in Alberta. The latter is divided into two bands, which formerly ranged respectively north and south of Bow River, from the Rocky Mountains out upon the prairies. Hector is chief of the southern band of the Canadian branch known locally as Bear's Paw band.

Plate 81 - Nez Percé Warrior, 1911

The office of chief was hereditary, but not strictly so, since public opinion could cause the rejection of an unfit heir. The old men and the warriors constituted an advisory body which, if its opinion ran counter to that of the chief, was expected to yield if he stood firm.

Plate 82 - Spotted Jack Rabbit—Apsaroke, 1909

Born 1864. Son of Shot In The Hand. At sixteen, having returned from his first war-party without accomplishing anything because a fall from his horse had broken his shoulder, he decided that he must gain power from the spirits by fasting. He went into the mountains, but received no vision. In all he fasted ten times, and at last was rewarded with a vision. He received no medicine from it, however, and was compelled to take that of his father.

Plate 83 - Lawyer—Nez Percé, 1911

The original of this portrait is a member of the family of that Lawyer who played a prominent part in Nez Percé affairs in the years following the treaty of 1855.

Plate 84 - A Flathead Chief, 1911

Through the medium of their annual incursions into the buffalo plains east of the Rocky Mountains, the Flatheads adopted much of the plains culture. Not only their domicile (the tipi), their garments, weapons, and articles of adornment, came from this source, but many of their dances were in imitation of similar ceremonies practiced by the prairie tribes. Prominent features of the accoutrement of this Flathead chief are his war-club of the plains type, and an eagle-bone whistle, such as was used in the Sun Dance.

Plate 85 - Buffalo Dance Costume, 1909

The Buffalo Dance was given in order to call the buffalo to various Indian villages in Northern New Mexico.

Plate 86 - Gray Bear—Yanktonai, 1908

Born in South Dakota in 1845. When fourteen years of age he joined a war-party, but achieved no honors. He fought against the Hidatsa, running down, while mounted, a horseless warrior and counting first coup. In another raid against the Hidatsa he successfully captured nine tethered horses on a dark and stormy night. Gray Bear's tutelary deities were the sun and the horses he rode in battle.

Plate 87 - A Piegan War-bonnet, 1928

The Piegans, though the same people as the Blackfeet and Bloods, imagine themselves to be a superior race, braver and more virtuous than their own countrymen, whom they always seem to despise for their vicious habits and treacherous conduct...War seems to be the Piegan's sole delight...one war-party no sooner arrives than another sets off.

Plate 88 - Cayuse Warrior, 1911

The Cayuse were a sullen, arrogant, warlike tribe ranging near the Blue Mountains, in Washington, and from the head of the Touchet River to that of John Day River, in Oregon.

Plate 89 - Sia Buffalo Mask, 1926

A close-up of a Buffalo Dancer whose function was to try to draw the buffalo to his village (Sia) in Northern New Mexico.

Plate 90 - The Three Chiefs—Piegan, 1911

Three proud old leaders of their people. A picture of the primal upland prairies with their waving grass and limpid streams. A glimpse of the life and conditions which are on the verge of extinction. Colodion Goldtoned Printing Out Paper Print.

Plate 91 - The Chief and His Staff—Apsaroke, 1909

Among the Apsaroke the chiefs were not elected; a man had a recognized standing according to his deeds, and so definite was the system of honors that there was never doubt as to the proper successor to the head-chieftainship.

Plate 92 - Sioux Camp, 1908

It was customary for a war-party to ride in circles about the tipi of their chief before starting on a raid into the country of the enemy.

Plate 93 - The Lookout—Apsaroke, 1909

In stature and in vigor the Apsaroke, or Crows, excelled all other tribes of the Rocky Mountain region, and were surpassed by none in bravery and in devotion to the supernatural forces that gave them strength against their enemies...

Plate 94 - Crying to the Spirits, 1909

This portrait of a Northern Plains male is from either Montana or the Western Dakotas. The buffalo robe hanging from the shoulders was part of the typical male dress.

Plate 95 - Shot in the Hand—Apsaroke, 1908

Born about 1841. By fasting he obtained his hawk-medicine; it was his custom to make a powder of a hawk's heart, sweet-grass, and green paint, and to eat a portion of the mixture just before going into battle.

Plate 96 - Nez Percé Brave, 1911

The Nez Percés are, by other tribes, given credit for a proud spirit which led them into deeds of great bravery...On the evening before their departure, the warriors, with perhaps a number of friends to assist in the singing, went from lodge to lodge with a dry, stiff rawhide on which they beat with switches, while singing their individual war-songs.

Plate 97 - Red Wing—Apsaroke, 1909

Born about 1858. Obtaining no medicine by fasting, he purchased that of brown crane and owl, and led a successful war party with it.

Plate 98 - A Hopi Man, 1922

In this physiognomy we read the dominant traits of Hopi character. The eyes speak of wariness, if not downright distrust. The mouth shows great possibilities of unyielding stubbornness. Yet somewhere in this face lurks an expression of masked warm-heartedness and humanity. Gelatin Silver Print.

Plate 99 - Red Cloud—Oglala, 1908

Born 1822. At the age of fifteen he accompanied a war-party which killed eighty Pawnee...Red Cloud received his name, in recognition of his bravery, from his father after the latter's death. Before that his name had been Two Arrows, Wă'-rĭ'ĭti...He first gained notice as a leader by his success at Fort Phil. Kearny in 1866, when he killed Captain Fetterman and eighty soldiers. He is well known for the following quote: "... I am poor and naked, but I am the chief of the nation. We do not want riches, but we want to train our children right. Riches would do us no good. We could not take them with us to the other world. We do not want riches. We want peace and love." Platinum Print.

Plate 100 - An Oasis in the Badlands, 1908

This picture was made in the heart of the Bad Lands of South Dakota. The subject is the sub-chief Red Hawk...Born in 1854. First war-party in 1865 under Crazy Horse, against troops. This is arguably Curtis' most classic and important Northern Plains landscape. Artistically, it is a highly realized and elegant image. Platinum Print.

Afterword - Geronimo—Apache, 1907

This portrait of the historical old Apache was made in March, 1905. According to Geronimo's calculation, he was seventy-six years of age, thus making the year of his birth 1829. The picture was taken at Carlisle, Pennsylvania, the day before the inauguration of President Roosevelt, Geronimo being one of the warriors who took part in the inaugural parade at Washington. He appreciated the honor of being one of those chosen for this occasion, and the catching of his features while the old warrior was in a retrospective mood was most fortunate.

About the Author

Christopher Cardozo is widely acknowledged as one of the world's leading authorities on the work of Edward S. Curtis. Cardozo first came upon Curtis' photographs in 1973 after returning from an eight-month photographic journey to a small, isolated Mexican Indian village. Many of the people he visited had seen few, if any, Whites, and many had never seen a photograph. Cardozo created an extensive body of work, making sepia-colored portraits and landscapes. After returning to the United States, he was shown a recently published book on Curtis. This first encounter with Curtis' work was a watershed experience and Cardozo began a thirty-year odyssey that has included collecting, researching, writing, lecturing, curating, publishing, and operating the most active Curtis gallery in the country for over a decade. Cardozo's own photographs of Mexican Indians have been widely exhibited and examples are in various museum collections, including the Museum of Modern Art in New York.

Cardozo has authored six previous books on Curtis and his unique personal Curtis collection is described below. Cardozo also founded the Edward S. Curtis Foundation, which is dedicated to cultivating an awareness and appreciation of Curtis and his work, and has begun to explore possibilities for creating a Curtis museum. In addition to his B.F.A. in photography and film, Cardozo is also trained as a lawyer and has lectured on art law. He is based in Minneapolis and has recently retired as a gallery owner to concentrate on his activities as a collector and private dealer, and once again to focus on his own artistic career and contemplative studies.

About the Collection

All photographs reproduced in this book are from the personal collection of Christopher Cardozo. He began collecting Edward Curtis' photographs thirty years ago, within hours of seeing his first original Curtis print. Since then, Cardozo has added over 4,000 vintage Curtis photographs to the collection, as well as hundreds of related objects and documents. The prints range from rare and/or unique prints that Curtis made, such as field prints, reference prints, experimental prints, special exhibition prints, etc., to the better-known photogravures. In all, the collection contains examples of Curtis' work in at least seven different media. Additionally, Cardozo has collected Curtis' original negatives, a camera, his wax cylinder sound recorder, business records, studio portraits, lecture notes, and promotional materials. In total, the collection comprises nearly 4,500 photographs and related objects, and is the largest and most broad-ranging Curtis collection in the world. In drawing from this collection to create this book, Cardozo attempted to bring many previously unpublished images to light, as well as to pay special attention to creating a strong and effective sequencing of images, which, coupled with strong juxtapositions, is intended to enable the viewer to fully appreciate the power and beauty of Curtis' photographs.

Acknowledgments

I wish to thank Gary Chassman of Verve Editions for his unflagging efforts in the realization of this book, as well as Anne Makepeace and Hartman Lomawaima for their gracious contributions. I particularly want to thank both Peter Bernardy and Julie Trombetta for their dedication, long hours, and support. I would also like to acknowledge Bulfinch Press and editor Michael Sand for their faith and commitment, without which this volume would not exist. Designer Stacey Hood's contributions are apparent throughout the book. Lastly, I would like to thank all the "great warriors" whose paths I have crossed and who have influenced me over the past thirty years, including the "young warriors" who are in my life: Peter and Max, Sean Smith, Ali and Kate, Adam Serna, Craig Begay, Bronson Begay, and the newest, Hunter and Bryce. For further information on the purchase of Edward S. Curtis' vintage or contemporary photographs, licensing rights, Curtis exhibition rentals, or for information on the current international museum tour of vintage Curtis photographs, including exhibition highlights and schedule, contact us at www.edwardcurtis.com or 1-888-328-7847.

Bulfinch Press
Time Warner Book Group
1271 Avenue of the Americas, New York, NY 10020
Visit our Web site at www.bulfinchpress.com

Developed and produced by Verve Editions and Christopher Cardozo, Inc.

Design by Stacey Hood

First Edition

ISBN 0-8212-2894-3

Library of Congress Control Number: 2003115134

PRINTED IN ITALY